Dear Navigator

Hu Fang

Dear Navigator

The Pavilion *Sternberg Press*

Volume 1

A Letter from Tropical Metropolis

Dear Phung Vo,
There is a suspicious color in the air here.
I don't dare breathe. I can't breathe. The reality
has been strengthening its body by using an
unknown stimulation and because of it we have
no way to express our melancholy. But tonight,
as I stuck my head out of that pathetic window,
that bright star appeared overhead, silent
and inexpressive. After the storm, the night sky
regained its mysterious dark-blue color and
looked as serene as the depths of the Medi-
terranean Sea. The sky, this friend that I have
missed for so long, embraced me with all of
itself. Its generosity defeated the desolate body
of reality. Even the lights from the tall build-
ings on the faraway horizon were warm, as
if they were the lights of fireflies, and humans
were able to get close again without the worry
of becoming hurt.

Besides the betrayal, do you still remember
the smell of fresh vegetables? Do you still run

around the city just for a particular spice, a piece of seaweed, a taste of areca palm? People have tried and tried again to speed up this subtropical slowness. When we saw the starry sky, we felt like children again and wondered: Will the structure of life tighten up so beautifully, just like twisted muscle and bone? People still wait for a transplantable lung from the dead. The death of one can bring life to others; a disaster for one may bring fortune to another. The tiny dust particles blown away by the storm will gather again one day because they cannot bear their own downfall.

We go back to our room, lock the door, shut the window, and switch on the light. We only read letters from the family and refuse to think about all the sorrows of everyday life, but they still slip through the cracks, letting in hallucinations of the disaster site. In many years, this will no longer be here. Will there still be a feeling of absence in the air? Will people not want to see electronic images stored in the electronic cloud anymore, just like they don't want to see old photographs? It was only our father's writing from long ago that was able to trigger secret tears—we were so rude to those who loved us so deeply. From here, I will finally

learn to face death calmly and to forget. In the end people will know if I have really lived, if there is such thing as a real life.

When our life is given back to the hands of time.

Wishing you good health!

<div align="right">A friend from far away</div>

<div align="right">*Translated by Fiona He*</div>

Volume I

Whale Song

In the beginning, there was only the sea.
Everything else had been forgotten. The waters
surged against the solid shore, sometimes fierce,
sometimes faint. Time passed. Blue shadows
and blue spirits began to take form, shyly crawl-
ing. Insinuating themselves into colonies,
they made their way from rock to rock, island
to island, traveling submerged at high tide,
staking a home when the waters receded. In the
beginning, nothing mattered. There were
no people. There were no structures where
these spirits could gather together. There was
only the sea and its solid shore. Time passed
and blue human forms began to take shape,
suspended between liquid and solid. The
waters still moved, sometimes fiercely, some-
times faintly. Everything else was forgotten.
There was only the sea and its blue spirits and
the restless rush of the waves ...

The sound of the pounding surf reaches my ears, sizzling like metal scraping together. Sometimes it gentles to the susurration of rustling plastic bags. I have realized that starting at my ears, everything begins to change. The moment the world enters my body it has already been transformed. The thing that reaches my brain is not what it started out to be. I believe coming here was the right thing to do. This city is forgiving enough to dispel any malaise.

XP stood by the window. The window in the building opposite seemed close enough to touch. The rough concrete wall and security grate were the only view he had, day in and day out. This exurban development was the place where he had spent his youth. The buildings were stacked so close together that no sunlight could penetrate, making it necessary to leave his fluorescent lamp on all day. The light illuminated the dust-filled room and its white walls, the debris-laden table, shriveled apple cores on the floor, dank green shower clogs, and the swaying clothes rack. It reflected off his face so his eye sockets appeared sunken, deep in shadow. Birthday cards were hung on the wall.

You never thought in your wildest dreams
that you would end up in a place like this.
When you were little, you dreamed about
having your own space someday, somewhere
you could live however you liked. It's as if some
great force has swept you here, like waves
vomiting debris from the ocean floor onto the
beach, washed up to stagnate in this murky
corner, to breathe the dank and stifling air.

XP felt the blood go to his head and he was
forced to lie back on the bed to try to calm his
breathing (visions of whales on the verge
of death floated through his mind). Tilting his
head to the left, he could hear his heart. The
sound gripped him as the blood flowed quickly
through his body.

The click of mah-jongg tiles from next
door blended with the noise of a TV upstairs.
Savory smells of stir-fry wafted in from the
back room of the beauty parlor below, and
in the distance the silent swell of the river could
be seen. The air would be fresher on the river-
bank. He should really make himself go for
a walk there every day to try to get his strength
back. He made himself a cup of tea. Moving
through the room, he picked up a newspaper
that had fallen to the floor. On the front page

was a photograph of the new Opera House,
which had just been built next to the river. It
consisted of two large boulder-like forms,
one white, one black, built together. It looked
as if two great meteorites had been placed in
the center of the city. His attention was drawn
to the space between the forms. It was like
an unplumbed gorge, framed by two perfectly
smooth slopes, as silken as flesh. XP was seized
by the urge to go inside.

*In my dream I'm running, my legs sore and
aching, running from one meadow toward
another. It's snowing and everything is white.
Silver icicles hang from the trees, as beautiful
as crystal. A car inches its way forward, slipping
and sliding. I say to myself, it's perfectly safe,
there's no danger here at all.*

He had episodes of numbness, radiating out
from his upper legs. When he woke up in the
morning, he often couldn't get out of bed right
away. His muscles hung slackly on his bones,
like some unresponsive, disintegrating mass.
It took all of his concentration to get the energy
moving though his body again.

I feel like I'm gradually rotting away. Every day my walks get shorter. My inner shadows make their way to the surface of my body; the evidence of my jaundiced, withered skin is inescapable (like dried-up leaves on a dead tree, falling to the ground, one by one). Only after I take my meds can I can pull myself together. Only then does the tattered strip of paper fluttering from the window across the way come into focus, the shredded remains of memory. The sunlight is beautiful, but it's not meant for me. The chilly waves turn inexorably in and out. This is their fate. It seems to be mine as well.

XP's health continued to fail until finally the day came when his life force reached its lowest ebb. He found himself immersed in memories of the time when his life was just opening out before him. This had been a three-month period of intensive study when he and his instructor watched videos to analyze the psychology of women. They went to bars and dance halls for on-the-job training in the techniques for their very special calling. XP immersed himself in women's fashion and glamour, and he learned what entertainments, sports, and lifestyles appealed to them.

"Life is bitter and short," his instructor told him. "The richest bloom of a person's life only lasts for two or three years. Our job is to channel our passion to restore the spring-time of our clients' youth. This is a great and noble calling."

Looking back now, XP felt that those three months were the best of his life — the time when his energy burned hotter than it ever would again.

Ah K, the boss, was quite happy with him, and soon told him that he was ready to start. On his first day, XP didn't do any work. He was given a red envelope containing one thousand yuan, which Ah K told him was the traditional introduction to their profession. Ah K also revealed to him the most important rule of their calling: never ask about or reveal a client's secrets. With his glasses and meticulously styled hair, and his slow, inflectionless speech, Ah K always made his meaning very clear.

XP wasn't assigned any clients that first day. Instead, he went to a special studio to get his picture taken. Ah K explained that clients would use these photos to make their selection so he should try to look as "sophisticated" as possible. The photographer directed him up a

steep flight of wooden stairs into the attic studio. There was only one small window, which looked out onto the corner of the middle school athletic field across the way. The field was deserted as the students were all in class. He sat there staring at the lens of the camera, not daring to blink.

"Turn this way a little, a little more, that's it, good!"

After that, he spent his days shuttling between hotels. The sound of elevators whooshing up and down was the prelude to his work. Sometimes he would take a pill ahead of time to ensure that he could perform at his very best. Of course, he didn't need to do this very often. He felt like he was living a dream. Bodies of every shape and size, thirsting and yearning, were opening up to him without reservation. And these women paid him for it! More than once, he observed that because it was a commercial transaction, they could reveal to him parts of themselves that they would otherwise keep hidden, too embarrassed to let anyone see. This moved him deeply.

Sometimes he would accompany his clients when they went shopping. On his way to serve a client's desires, he could feel the heart of the

city quivering in anticipation of the pleasures to come.

> *I don't think there's anyone who has a deeper connection to this city than I do. I pour my body and soul into my work; I channel the city's passion through my body to satisfy flesh that is awash with desire. I enable these women to experience the immense joy of life in the city. This is the source of my joy. You are happy, so I am happy.*

Deep in the night, lying alone in bed, the cell phone rings. The women pour out their hearts to him, while he leafs through newspaper and magazine columns about life in the city. Sometimes he satisfies them, moaning into the phone. Sometimes, the connection is broken and silence once more fills the room. Outside the window, a plane streaks through the night like a shooting star rushing passengers into the city, and the high-rise buildings look like ghostly fingers reaching into the heavens. Beyond his star-filled window awaits the joy his clients have come so far to find.

The soft night envelops him. It's like he's cocooned in a dark cave, warm and close. The

lamplight falls gently on the medicine on the table, the pills in their blister packs look like ranks of bombers arrayed on the glass tabletop. Silver condom wrappers glint in the light. He reaches out, rips one open, and runs his fingernail along the slick membrane.

His health has been declining imperceptibly. No one knows what is really wrong, just like no one could really plumb the depths of the city's desire (if only they could determine the cause, then there might be hope for a cure).

Finally, the day came when XP passed out in a client's bed. Of course, the client was dissatisfied. Ah K gave him a severe talking-to, telling him he had to pull himself together.

"You're just getting started," he said. "You could be living in paradise before long."

Later, after XP had recovered from the incident, all he could remember was an endless tunnel opening up before him, with a hint of light in the distance. He had wanted to go toward it, but he was so weak that he couldn't even crawl.

"Take it easy for a few days. I'll page you later," Ah K told him impatiently.

Just when XP was feeling at his lowest, he read in the paper about a pod of whales that

had committed mass suicide by stranding themselves on the city beach. His heart seized up. He lay in bed, feeling like a sailor in distress, tossed on the waves of a dark and limitless sea. Strangely, he wasn't at all afraid. Maybe he had been born with no fear of death. Maybe he was meant to find pleasure in everything around him. That evening, he turned on the TV and saw crowds of people trying to push the whales back into the sea. But their skin adhered so tightly to the beach that they couldn't be budged at all. Large tractors were moved in, but when they tried to push against the whales' heads, the machines reared up and tipped over. There was nothing anyone could do. More than thirty huge whales lay scattered across the beach, making the long sweep of sand, usually so clean and open, appear strangely cluttered.

A biologist made an appearance in the TV news studio, responding to the news anchor's questions with great authority. Apparently the biologist had prepared a thorough presentation.

"The reason for mass suicides by whales is complex and not very well understood. It is generally believed that whales run aground when their echolocation function fails. Sloping

sandy coastlines may prevent them from acquiring accurate sonar data, causing them to lose their way."

"But why do they commit mass suicide?"

"This phenomenon is still a mystery. But we surmise that the first whale to run aground emits a sonic distress call. Every whale of the same species within hearing distance then rushes in to try to provide aid. Their instinct to protect their fellows is so great," the biologist gestured emphatically, "that they disregard any danger to themselves. The result is this terrible tragedy."

"Are humans capable of monitoring the whales' cries for help?"

"Ah, these cries ... they are songs of despair. They are emitted at such a high frequency that human ears could never detect them."

The biologist became visibly agitated.

The anchor quickly switched views. "What a terrible thing. Now let's return to the live scene."

The beach was eerily calm. Under the leaden sky, the whales gazed sorrowfully at the people stumbling around them. The ridges of their glistening smooth backs were naked to the air. XP suddenly realized how erotic the ridge of a whale's back is.

*The anatomy of human skin resembles the layers
of the earth's crust: from the pores, epidermis,
dermis, and sweat glands to the deep fascia and
muscles beneath. I can distinctly feel the deterio-
ration of my body. Deep in the night, the sound
of my interior disintegration is even more
gripping. My ears greedily reach for and absorb
this sound so I can participate in my own decay.
The various parts of my body no longer work
in concert. Rather, they are engaged in a process
of mutual destruction. All I can do is listen
submissively ...*

Waiting is all that is left for XP now. Every day
he thinks about going to take a walk by the
river, but he's so debilitated that he has to give
up and falls back onto the bed. Sometimes
the constant high ringing in his ears gets so
loud that he starts to hallucinate, imagining
that he's hearing a whale song. He tries
to distinguish the components of the sound:
Which is the "socializing song" of the whales
gamboling in the water? Which is the "love
song" of their mating? Which is the "gathering
song" of the pod seeking food? Who would
have thought he would be able find such pleas-
ure in this?

A cockroach crawls up the wall beside the bed, stopping just below XP's eye. Gathering his strength, he pulls himself up out of bed and flicks the cockroach to the ground. It lands with a bump and lies momentarily stunned on the floor. XP is so agitated that his calf starts to spasm, but he brings it under control. He steps on the cockroach. XP takes off his shoe, flips the cockroach into the toilet and watches as it's caught in the whirlpool of flushing water and sucked into the unknown depths.

He finally went to visit the Opera House. From one side of the Guangzhou Bridge, XP could clearly see the great geometric form he had studied so many times in a photograph. Illuminated by the setting sun, it resembled an abstract mountain range; its silhouette was breathtaking. He noticed that the surface of the structure was as smooth and glossy as the skin of a whale's back. He was especially struck by the arm-like structures that extended from the building's central complex. They seemed almost organic, radiating out in every direction like the tentacles of an octopus. The arms that reached toward the river sloped down and disappeared without a trace as if they were sucked into the earth.

When he got inside, the lobby was packed with a large, noisy crowd of people excitedly pointing things out to each other. It reminded him of a scene from a prison exercise yard. The buzzing of conversation was like wind blowing in from a mountain gorge.

The performance started. The sound of the instruments immediately heightened the sound of ringing in my ears. Even worse, the nausea I frequently experienced resurged once more and I had no choice but to slip out of the hall. In the now deserted lobby, the ceiling lamps cast a quiet and neutral light, and the ringing in my ears abated slightly. As I looked around for the restroom, I noticed a door at the top of a ramp, slightly ajar.

I went up the ramp and pushed the door open (this exhausted every bit of strength I had). Much to my surprise, a small room was revealed (once more the sterile prison came to mind) and inside were two young people dressed in suits, gesturing inexplicably. They appeared to be Eurasian, and were both quite androgynous. The only sexual characteristics I could distinguish were that the taller one's face was dusted with peach fuzz, while the shorter one's skin was smooth and pale. They didn't allow my appearance to immediately interrupt their motions, but soon enough they stopped and beckoned me to come closer.

"Who are you?" I asked.

"We are artists," they answered.

I was surprised that I couldn't hear any trace of an accent when they spoke Mandarin.

"This is a menu of our performance art. You can buy any item and we'll perform it for you on the spot."

They passed me a piece of A4 typing paper. On it, arranged like a menu in a restaurant, were columns of titles and corresponding prices. They pointed out the categories listed at the top.

"If you're lucky, you might even receive a souvenir of the performance."

I looked at the menu. The variety of titles exhausted me, flooding my mind with a multitude of images. One category offered impersonations of famous people, from Marilyn Monroe to Buddha. Another was about everyday objects, with titles ranging from "All That Exists Is the Right Foot's Sock" to "The Screaming Plastic Cup." Another category involved abstract emotions, such as "Jealousy" and "Hatred." Yet another was concerned with sociology, anthropology, and biology, with topics like "Man/Woman" and "Human/Animal."

I chose the item "Boy and Girl." The taller of the two looked at my selection carefully for a moment. Regretfully he said, "I'm sorry, that one is sold out."

"Really?" I studied the menu intently, as if this could tell me if I was about to be tricked.

"How about this one: 'Calligraphy in White'?"

"That will be thirty yuan, please."

They took my money, taking my change out of a cash box like the ones used by shopkeepers.

They retreated to the corner where they took some objects out of a cabinet and put

them in their pockets. They then strode over to the center of the room. Together they looked up at the ceiling. After a moment, the taller one pulled a small white object out of his pocket. He squatted down on his heels and placed the object on the floor.

"Yes," he said.

The shorter one turned slightly.

"Oh yes," he said.

He also pulled a small white object out of his pocket and placed it on the floor. They separated. The taller one moved to face me and put something on the floor at my feet.

"Oh yes," he said.

It was a small white plastic X.

"Oh yes, oh yes," he said, and immediately placed two more Xs by my feet.

The shorter one chimed in. "Yes, yes." He put down two Xs, thought for a moment, and put down two more.

The taller one seemed to be searching for a more suitable location. He eyed the distance from the window to the door, and then deliberately placed an X at the center of the line between the two. "Yes." He seemed quite satisfied with the result. Reassured, he threw down another X. "Oh yes."

The shorter one became very excited. "Yes, yes, yes!" he yelled, and threw three Xs down in the corner, one after another.

The taller one turned around. He looked at me questioningly, and very carefully threw an X down between us. "Oh yes."

He gazed at me steadily, not quite smiling. The shorter one came striding over to stand in front of me.

"Yes," he said loudly.

Raising his arm high in an exaggerated gesture, he let an X fall from his hand. He then dropped several more, as if confirming the correctness of his action.

The space around my feet quickly filled up with Xs. I was merely an observer for the entire process, although I had to stifle a laugh several times. More and more Xs piled up on the floor, accompanied by the call and response of "yes" and "oh yes," high and low, loud and soft, submissive and commanding, certain and skeptical, increasingly circumscribing the available floor space.

Suddenly the taller one impetuously flung down a large number of Xs, hastily crying out "oh yes oh yes oh yes" as if trying to get the words out before the Xs hit the ground. Finally

he abruptly turned his pockets inside out and watched the remaining Xs fall to the floor, as if he really couldn't care less what anyone thought. The shorter one stood to the side looking stunned, uttering a constant stream of "yes yes yes," as if attempting to make up for the taller one's irresponsible actions. In the end, they both stood silently regarding the Xs on the floor for a long time.

They took a bow together, and withdrew to the cabinet in the corner of the room.

As I applauded, I realized that at some point I had collapsed, and was sitting limply on the floor.

They approached me once more. "Thank you. You may select any X you like."

I looked around and picked up one of the closest ones.

"Excellent!" the taller one said effusively. "We will mail this to you at the first possible opportunity. Now, please fill out this form."

As I put pen to paper, I felt like I was signing some invisible contract.

"Very good. Would you like to order anything else?" He handed me the menu once more.

If they were willing, maybe they could use

their art to plumb the depths of life. If I had enough time, maybe I could watch an entire life recreated here before my eyes. And watching this performance, my life would be exhausted before I knew it.

A frightening silence filled the room.

I realized I had to get out of there, or this might become a performance I could never leave. Out of the corner of my eye, I glimpsed the item "Opera House" on the menu.

"I'll take this one," I said.

They regarded the list. "Ah, a fine selection. Now we can finally go home for the day. Thank you, that will be fifty yuan."

They proceeded in opposite directions around the perimeter of the room. Then they switched directions and made another circuit, following a strict linear pattern. Meeting at a doorway I hadn't noticed before, they exited together. The room was filled with Xs.

The door through which they had disappeared was slightly ajar. Gingerly I pushed it open. I was greeted with a gust of rank air, like the stench of a subway station mingled with rotting vegetables. All I could see was a dark expanse. As my eyes adjusted to the gloom, I made out tracks stretching into the distance.

On one side of the tracks, two people were smiling at me.

"Have a good trip!" they called out merrily, and once more disappeared from sight.

I could clearly hear the sound of the ocean. Maybe the organic form of the Opera House enabled parts of the structure to vibrate in tune with the harmonics of the waves. The ringing in my ears faded away and unconsciously I moved forward. I couldn't see anything, but strangely I wasn't at all afraid. Maybe I was born with no fear of death. Maybe I was meant to find pleasure in everything around me. I had had a crazy youth, but that was no one's fault. Maybe this city would remember me, remember the joy I had brought to those women. The whales yawned. This was a barren place that would never bring forth life, but it didn't begrudge the life that already existed. I could only bury my head in the darkness of the underground and wait for the rusted drill to burrow through the earth above, for the tractors to fill the sky with dirt ... Although buried deep in darkness, cocooned in ignorance, I also felt release. My head was too heavy to lift (maybe due to lack of oxygen). There were no signs to point the way. I only knew that I was

getting closer and closer. The rush of the waves,
the surge of the sea, the glistening, naked backs
of the distant whales, the piercing, echoing
cries for help ... it was for this that I dragged
my cracking, brittle bones along:

> *That place is fresh and cool*
> *Outside of life and time*
> *I will not live nor will I die*
> *I hear the song of the whale*

The boundless city stretches and grows behind
him like a contagion. He muses to himself:
if only someone else is happy, that's enough.

Translated by R. B. Baron

Facade

1.0

And it came to pass, as they journeyed from the east, that they found a plain in the land of Shinar; and they dwelt there. And they said one to another, Go to, let us make brick, and burn them throughly. And they had brick for stone, and slime had they for morter. And they said, Go to, let us build us a city and a tower, whose top may reach unto heaven ...

Genesis 11:2–4

1.1

This is how the world is born.

Between the tubes and pipes that plunge into the earth; between windowpane and sunbeam swirling motes of dust ...

The architect scrawls on a blank space of his architectural diagram: "People are like beasts, pacing and crying out within their glass enclosures. This feeling appeals to me. What people really need isn't ease and comfort but rather a stage upon which to battle and perform ..."

1.2

From the outside, the Triple A Office Tower resembles a seamless column, free of the traditional building blocks of front, back, side, and roof. The architect has wrapped his creation in a skin of LED light, the most vibrant and exciting element of this city.

The tower's glass facade consists of seven repeating upright sections. Vertical members called mullions divide alternating panels of light and dark blue glass, and tubular neon lights spiral upward around the column. Each section uses glass that is either 1050 mm, 1160 mm, or 1360 mm thick, creating the sense of an irregular surface. The panels of glass that comprise the facade are arranged in a multiplicity of patterns, secured to the underlying structure and delineated by free-floating mullions of varying length.

What the architect intends to convey is this: when night falls, this building becomes as capricious as a lover's emotions.

Facade defines this structure: attempt to grasp its form and it simply disappears.

1.3

About glass: The molecular structure of glass consists of one atom of silicon surrounded by several atoms of oxygen. These silicon-oxygen molecules link together to form a three-dimensional matrix, with atoms of sodium randomly distributed throughout. It is important to note that the atoms of each silicon-oxygen molecule are bonded in a specific configuration. Where there is an atom of silicon, there are sure to be adjacent atoms of oxygen. (This configuration is similar to the layout of Windows Minesweeper.) In this regard, glass resembles a solid.

But unlike the fixed bonds between each molecule's component atoms, the links among the silicon-oxygen molecules are random and unpredictable. This creates a fluid matrix, giving glass the characteristic of an amorphous liquid.

The fact that glass simultaneously exhibits the qualities of both a liquid and a solid exerts a deep fascination.

Within its internal matrix, glass flows at an infinitesimal rate.

It would probably take a thousand years to pour out a cup of glass.

If you wait long enough, the day will come when every glass building will have slumped back to the earth, silica hills refracting rainbow rays of setting sun.

1.4

Who would have thought that this city would vanish like smoke in an instant? Such imposing vistas. Great viaducts one hundred meters high crashing down onto ant-like crowds of people, their faces flushed red by fragments of neon lights!

Screaming!

CUT!

Let's try this again.

A model pouts. *You can forget hooking up with me tonight!*

Determining the value of an exchange.

This appeals to me.

A story about the flush of youth, the source of desire: I'm afraid no one really cares.

That face.

Let's try this again.

People are like wind-up toys, starting over again each time their string is pulled. Lips curve into an enticing smile and suddenly I realize: nothing really matters.

We encircle a young model like a pack of predators stalking our next dinner.

We hope her passion may be sparked by a photoflood lamp, a beacon shining ever brighter. While for us, our lust turns to vapor in a world of gray, eventually condensing into color pictures in a magazine or posters at a bus stop.

This is the essence of collective desire.

1.5

Each face of the Triple A Office Tower has a unique relationship with the city, converging to draw attention to the building's primary element: its facade.

A slight asymmetry defines the upper east section of the tower. Although this feature is barely noticeable, it is crucial to the viewer's overall impression of the building. At night, floodlights illuminate this irregularity, emphasizing the interplay between the tower's top and bottom halves.

This is the embodiment of my fluctuating emotions.

1.6

Car lights flash on the steel rails of the bus stop, painfully stabbing my eyes.

I spot a face full of dismay, reflected in a light-box advertisement.

In this instant, I realize: *furniture is the embodiment of desire.*

My inconstant empathy, the nerve endings of my brain, reach out to caress the surface of an Italian sofa as if it were her skin.

My fingernails dig deep into her flesh, tattooing a lasting memento.

This is universal. Shout until you're hoarse: don't forget me.

Actually, she and I are no different.

Her teeth have left deep impressions upon my skin; you can clearly see where there is a gap between her teeth.

This is the mark of personal possession.

2.0

This building is evolving. I distinctly hear something that sounds like chewing. Inside the tower, dust motes swirl and collide. Blue sunbeams filter through the glass, illuminating every corner. Women glide by like marine creatures at the bottom of the sea; dressed in business suits they pass before me in slow motion, one by one. Office supplies, no longer inert and lifeless, are transfigured into living

organs within the tower's skin.

I am just another one of the tower's perambulating cells. But this cell can feel the future.

I lack for nothing as the building evolves. Facade defines this structure: attempt to grasp its form and it simply disappears.

2.1

"I'm flying to Beijing on the eighteenth to work on my film."

"I guess I won't be seeing you, then ..."

"You don't want to see me?"

I hang up the phone; traces of her warmth still linger in my ear.

Unconsciously my fingernails trace the surface of the glass table as if it were her skin.

On the seventy-eighth floor, clouds swirl by outside the window, revealing glimpses of the chaotic and fascinating city below.

2.2

Furniture always seems fresh and new at first, like roses you've just brought home.

Studio 65's 1970s red-lips sofa is as voluptuous as a young woman's kiss.

A hanging white chair in the shape of a sphere embraces you like a warm and

welcoming womb.

You feel that there are no boundaries between objects; only space suffused with simple happiness.

Lightly you caress the red lips' silky surface. Your butt burrows into the space where top and bottom kiss.

From a distance, it seems you're gently held between two huge lips, blissfully suspended in maternal love.

You start to fidget and the lips tremble uneasily in response.

What is it that you want to say?

Even furniture has the right to express itself.

Each piece of furniture is created, molded into its unique and individual form. When every chair has done its utmost to perfectly contain each set of buttocks, it is certain that they will say: "We feel your heartbeat and your frustration, we experience your animal warmth …"

Ideally, furniture can relieve us of our anxiety.

Through its perfection, it mellows and exalts us.

In this respect, furniture functions like the Greek tragedies extolled by Aristotle.

2.3

Heading home.

I need that brilliant path of light to show me the way.

Stopping at my turnoff for a smoke, I take a deep drag and the pine trees in front of me burst into flame.

3.0

In an interview with a reporter from Star TV, the architect states: "Buildings are receptacles that must endure people's timidity, agitation, and arrogance. They provide a stage where the battle between individuals transforms into the struggle with oneself."

3.1

Another time, I'm in the Triple A Office Tower. Outside the boardroom's wall of glass, shafts of sunlight intermittently pierce through the clouds. In the distance, skyscrapers flicker like a mirage. A pair of newlyweds takes pictures in the broad plaza far below. Although they appear as small as ants, their joyous cavorting is clear to see.

I keep thinking over Company K's advertising campaign.

Their slogan repeats in my head: "Company K: Accompany You Home."

3.2

When 9/11 happened, I was holed up in a luxurious bathroom in Sanya, sitting on the toilet smoking a cigarette.

Reflected TV images flash in the bathroom mirror.

For a split second history ruptures, only to rush forward again more violently than before.

I immediately think of the Triple A Office Tower. Always so brilliant and glittering, at this moment it must be totally eclipsed.

In an instant, the soft yellow bathroom enfolds me like a womb and the pristine white Kohler toilet becomes the foundation of my continuing existence.

3.3

The architect once explained that a building's facade is neutral by nature, changing along with the unpredictable emotions of its people and its city. It is through this neutrality that we find a shortcut to self-realization.

Is there any place so neutral that it will never be defiled by history?

3.4

As I make my way home that day, I notice for the first time that the grove of pine trees at my turnoff is haloed with pink.

A subaudible electrical humming beats against my skull, a song of my socialistic childhood:

We take up oars, and send our boat through
 surging waves ...
Unceasing repetition. Reverberation.
A pink utopia, rippling with emerald waves.

Family and company, peacefully coexisting.
Happiness and capital, peacefully coexisting.
Wife and lover, peacefully coexisting.

The desire for neutrality.
The happiness of neutrality.

3.5

I have realized that the Corbusier chaise longue that appears in my dreams actually represents my vision of neutrality.

Its steel frame and padding embody masculinity, while its curvaceous form is the essence of the feminine.

Perhaps furniture creates a sense of ambiguity within a consumer culture that is defined by the hierarchy of gender. The perfection of its neutrality exalts us, like the tragedy of the purification.

3.6

I caress the plastic wrap that binds my office chairs, so tender and green that my heart aches.

(Strangely, lately I keep thinking of a Buddhist sutra by the Sixth Zen Patriarch Hui Neng.)

Only I can caress them; only I can possess them.

(*"When mental activity begins, various things come into being; when mental activity ceases, they too cease to exist."*)

This is how love and violence spring from the same source.

The architect's statement in *IQ Men* magazine comes to mind: "This space was created for people who are passionate about life so they can enjoy the moment of peace that follows battle."

3·7

Suffused in the brilliant red glow of the setting sun, I once more make my way home. Somehow, the sunset makes me feel even more conflicted. I always stop at the turnoff to Clifford Villa House to have a smoke and watch the sun sink behind the trees.

The scent of the neighborhood plantings is brilliant and beguiling.

The only thing that really makes sense is the road that leads me home.

The rays of the setting sun reflect off kitchen pots and pans, and my heart swells with warmth. The distant mountains are wreathed in a halo of light!

If a miracle doesn't occur at this instant, I'll no longer believe in life.

Translated by R. B. Baron

Volume 2

Notes from the Glass House

I am particularly fond of this story: seven men and seven women who do not know one another live in a glass house for one month. Under these circumstances, because it is required that they sever all ties with their previous way of life, they develop a new dynamic among themselves, sparking off the fundamental emotions of humankind — love, desire, passion, and hatred.

During the first week, their caution toward each other is evident. They tentatively attempt to communicate to one another, each tapping in on their past glories or social status to get into the good books of others. However, all that happens within the glass house is as convincing as empty promises. Gradually, they realize that the sole elements leading to victory are their own beings and the purity and simplicity of words; it is these things that are needed to reveal a "true self" to others.

Everything in this closed, transparent space is captured by video cameras. Viewers from all

over the country are gathered around their
television sets, watching the participants' every
move with intense interest, whipping out their
cell phones to send text messages to one
another.

At times, the participants wonder if they
should seek help from the director, admit to
their personal weaknesses, and then withdraw
from the competition. But the lure of millions
of dollars in prize money is irresistible (every-
one has valid reasons for why they ought to
win) — they are also constrained by personal
pride, hence no one allows himself or herself
to give up too easily. Some of the participants
endure sleepless nights, and their loved ones,
following their struggles as observed by the
camera, consequently suffer the same insomnia
with them. How difficult it is to make the right
decision!

As required, each of them has to say a few
words via the camera to their loved ones each
day; most of the time this revolves around their
recollections on the past, realizations about
life, and confessions when their consciences are
pricked. These in turn elicit widespread
national tears. When the participants look
right into the camera and speak with deep

emotions, in actual fact, they are gazing at the audience, confiding in them with great sentiment. Time and time again, this experience reminds them: what is important is not leaving a good impression on the opposite sex in the house, but rather on winning the favor of the audiences outside. The participants' indistinct views, when projected beyond the glass house via the cameras, are akin to messages sent from Earth into the dark unknown that is outer space.

Finally, two of the participants kiss. Their profound love spurs on another pair unwilling to be left behind to embrace each other. This incredibly lucid and protracted feature story drives their loved ones outside of the glass house to resort to smashing up their television sets in a bid to break that endless kiss.

The fragments of the television set are symbolic of the shattering of the glass house. Yet the image of the kissing lovers remains deeply seared into the minds of every man or woman watching. It has become an indelible memory in their lives.

In my youth, I dreamed of becoming the director of that "tragicomic reality show." As the participants are wrapped up in their

passionate embraces, I would have the shot cut to a series of personal, private spaces, to focus on the despair on the face of a man or woman sitting before the television.

Translated by Melissa Lim

The Hunger Artist Wu Yongfang

The hunger artist reappeared on our radar several years after his original performance. An unexpected storm of controversy swept through society and the Internet when some old photographs from the event were posted on the Tianya virtual community website. The severely emaciated hunger artist Wu Yongfang sits upright, staring directly into the camera. He's naked except for a white loincloth wound around his waist like Gandhi, leaving almost nothing to the imagination. As we look through the iron bars that separate him from the audience, we see that the room in which he sits is as austere as a prisoner's cell, furnished only with a mat and a cot. An exterior view reveals that this "prison cell" is a temporary bamboo hut, perched on the roof of a geometric three-story building. The bamboo adds a fashionable flavor of environmental awareness to the modern structure. From the captions that accompany the photos, we learn that the

building houses the real estate offices of Company X, which organized and sponsored the event. The temporary hut, designated the "fasting room," was designed and constructed especially for the hunger artist using all recyclable materials. It's common knowledge around town that now, many years later, Company X has just launched a new marketing campaign for its Free Spirit Leisure Villas, a huge five-thousand-acre adult-living waterfront development.

The crux of the debate raging online is this: The hunger artist's detractors maintain that although hunger remains a chronic social problem that must be eliminated, the economy of Country Y has been growing steadily and the lives of people living there have improved significantly. But if the hunger artist persists in displaying images of poverty and backwardness to domestic audiences and the entire world, isn't he building his artistic success on the back of the disadvantaged? His supporters, on the other hand, maintain that the hunger artist's actions embody his immense courage, as he risks his life to shock us into confronting reality.

After several thousand posts make the rounds on the Internet, both sides of the debate

spontaneously arrive at the same suspicion: Could this controversy just be a new marketing ploy on the part of the real estate company?

"I've been planning this event with my curator for a long time. My curator is an old friend of Mr. Liang, from the real estate sales department in Company X. Mr. Liang has always had strong opinions about culture and he wanted to support our creative endeavor by providing us with this venue. I think we're going to attract even more attention and debate by holding the event at a busy commercial center like this."

Wu Yongfang responds to questions from the crowd.

"Is the purpose of the event to raise awareness about poverty?"

"Of course; that goes without saying. But we also want to focus attention on cutting-edge trends in art."

"Ah, so you want to educate the public about performance art!"

A light bulb seems to go off over the questioner's head — in Country Z, any work of art that people don't understand or don't like is usually referred to as "performance art."

"I know what you mean by performance art,

but I prefer to call what I do 'life art.' I use my life force as a medium for creative expression — we still don't know what the final result will be."

"Do you know what your physical limitations are? Are you worried about that? Do the limits of the body define the limits of creativity?"

"I'm not worried. You could say that I'm using the creative process to explore the limits of my own willpower."

An endless stream of people surge toward the prison cell that is perched on the roof of Company X's real estate office. Wu Yongfang gazes out at them, silent and content. The crowds have been huge for the last three days, much bigger than for any of his previous exhibitions.

Wu Yongfang's favorite time of day is when light gives way to night. The crowds thin out and dusk overtakes his small cell. It is a time when limitless possibilities emerge. Silently he stands up, unsure of where in space his body is located. A hallucinatory mixture of exhaustion and extreme, prolonged hunger beguiles him. In the faint light, he sees his own seated figure floating before him like the Zen master Bodhidharma sunk deep in meditation.

He recalls the moment deep into his fast, after starvation had set in, when a rush of warmth suddenly rose up from his *hara*, the seat of his life force. Surging to the top of his head, it assured him that his willpower had been fully roused. His eyes scintillate with energy. The audience gazes at him reverently, intensifying the warmth he feels.

The reverence the audience feels for the artist is reciprocated by the artist's desire to illuminate the audience. First he tells them about the difference between therapeutic fasting and hunger art. Then he stresses the importance of distinguishing traditional hunger strikers from contemporary hunger artists. Hunger strikers make their living from fasting in public, he explains; they traditionally appear in social and political venues, carrying out a form of passive resistance. Many hunger strike manifestos that have been passed down through the ages bear witness to this. Hunger artists, on the other hand, do not intend to express resistance of any sort through their public fasting. Rather, they employ the traditional methods of the hunger strike to undertake a *contemporary creative process*. By reawakening the taste of hunger, something that most

people have forgotten — arousing a sense of nostalgia, so to speak — hunger artists stimulate and heighten self-awareness, and provoke intense contemplation of the relationship between self and society.

He explains the historical basis of hunger art to the crowd: "When I was little, we lived through three years of natural disaster. We ate anything we could find, even weeds and tree roots, until there was nothing left."

"Yeah, but at least it was green food."

It's hard to tell if this young spectator is joking or is really totally clueless about history.

A group of chattering students is led toward the hunger artist by their teacher. They regard him fearfully. He immediately has a vision of what the curriculum on hunger will be like in the future: hunger will no longer be a physical experience; rather it will have become a memory, used only to evoke the performances of hunger artists. *I realize that in order to reach the pinnacle of my art, I must become completely genuine.*

"I hate the idea of performing. That's why I call myself an artist of life."

Despite his explanations, the media insists on using provocative headlines such as

"Hunger Strike at Luxury Development" and "Therapeutic Fasting at Free Spirit Leisure Villas," when reporting on the event. Of course, the hunger artist has no real interest in the relationship between his art and how many units of luxury housing are being sold. He only wants to see his audience. He only hopes that as countless spectators fix him with their reverential gaze, he may leave imprinted on their consciousness the image of a true modern-day Bodhidharma.

Interestingly, many people aren't satisfied just looking at his body. They also want to stick their noses through the iron bars to try to capture his scent, and they conclude that the reason the hunger artist smells so healthy is because fasting prevents the consumption of contaminated food.

After the crowd is done viewing the hunger artist, they go downstairs to the real estate office where they are once more immersed in breathless sales pitches for luxury waterfront housing and are confronted with the endless headaches of the real estate market. This mingling of scents, of asceticism and consumerism, creates a unique artistic experience.

The hunger artist announced that he

intended to keep going, to test his limits to the utmost, after completing the first phase of his event. The organizers were somewhat hesitant. They were very happy with the public response so far, but at the same time they were worried that the hunger artist might not be physically up to the challenge and that unforeseen problems might arise. But the hunger artist was steadfast in his demand. There was a surge of public opposition against allowing him to continue his fast. But after he underwent a thorough physical examination and signed a renewed waiver of liability in the event of his death, it was finally decided to continue the event.

Within several days, the hunger artist felt that he had achieved an unprecedented level of purification. *Maybe in the beginning there was no difference between hunger art and hunger strikes. Maybe it was only the process of cultural development that caused them to become two different things. But now, they are being reunited in the crucible of my body to create a new school of hunger art.*

In the future, artists of the hunger school will measure themselves not only by the duration of their hunger, but also by the extent of their social relevance. In this way, they will

determine whose work is the most powerful.

No one was really surprised when a strange new phenomenon emerged. A hunger art exhibition was mounted to publicize a real estate development called "Fragrant Garden Villas," but in this case, the promotional materials sensationalized the fact that the hunger artist was a beautiful woman. Members of the public started to question the organizers' increasingly strident exploitation of human life for commercial gain and a number of people started to hold protests in front of the building.

As for Wu Yongfang, after prolonged disputes and negotiations, the organizers of his event forcefully "requested" him to vacate the fasting room and he was transported directly to a local hospital to recuperate. Upon his release from the hospital, he immediately took the organizers to court.

"I spent two decades of my life preparing for this work of art. Unfortunately, I was deliberately prevented from completing my creative process. How many decades does a person have in one lifetime? We are living on the cusp between old and new eras. My situation highlights the fact that even now, our freedom of expression remains severely limited."

After emerging from the courthouse, the hunger artist responded to questions from the media: "There's something else I want to say. In this new age that lies before us, every single person is going to enjoy full freedom of expression. When I hold my next hunger art performance, I hope that this prediction will serve as my final words."

As he speaks, he puts a special emphasis on the phrase "my final words," as if his prediction has already come to pass.

The last time I saw Wu Yongfang was at an entertainment industry event held in memory of Michael Jackson. The theme was "eternal life." Even though it was a memorial, the atmosphere wasn't at all gloomy. In fact, it was a joyous celebration. When Wu Yongfang made an appearance, he was immediately surrounded by hordes of fans. By this time, he had been acclaimed the godfather of Country Z's School of Hunger Art. As he stood under the spotlights addressing the crowd, the profound import of what he said affected me deeply:

"Michael Jackson had been preparing for his death for a very long time. Why do I say this? He had already experienced the death of his physical body once, twice, countless times.

His physical body faded away long ago. It was transfigured into an image. He had been living inside his image for a long time. This final death was merely the realization of his eternal life. It is inevitable that the body will eventually disappear, but the image lives on forever. When his body finally died, I had a sudden realization."

He pauses for a moment under the spot-lights, a strange smile appearing on his face. "I realized that he and I have always been comrades in art. We are all comrades ... in hunger art!"

Passionately he raises his glass in a toast: "Come on, everybody! Let's drink to the brilliance of our comrades in art!"

Translated by R. B. Baron

Volume 2

The Shame of Participation[1]

The city had not seen snow for many years. When winter came, most people had only outmoded charcoal stoves to use for warmth, which clogged the air with suffocating smoke and stained the sky the color of scarlet, like the cheeks of a pneumonia patient. The air was also filled with the sounds of whispers about energy shortage, real estate contraction, and the all-out retreat of investors. As an attorney, I had long been without anything to do. Since people here could not even afford the basic expenses of a lawsuit, they usually relied on the "private settlement" method whenever a dispute arose.

I would go to work, check the news online, and would then eat hot pot with colleagues afterward. Everything was sustained on a fundamental equilibrium of income and expense. During the cold nights, curled up in

1. Editorial notes: The title of this story seems to both evoke and respond to that of Markus Miessen's book *The Nightmare of Participation*.

the covers to preserve bodily warmth, I would read a number of books, which, compared to daytime "social activities" — and all these activities only had the effect of making us feel more removed from real life — at least gave me a sense of peace.

On the coldest day of winter, we welcomed to our office two strangers dressed in fashionable blue windbreakers. They were carrying a letter of introduction from the city hall and had come to speak with all of us. Our director immediately stood up to greet them, confirming that he had already received the call from city hall and indicating that he would promptly cooperate with any government requests.

Subsequently, we came to understand that these two artists, active in all major national and international exhibitions, had been invited here by the city. They were undertaking a project that was commissioned by our floundering metropolis, because they had been deeply moved by their exchanges with our officials and believed that through the power of art they could resurrect the great spirit of the city and its people, a task they saw to be their responsibility as artists.

"You," they said as they pointed to my

colleagues and me, "are the real theme of this exhibition."

I felt a kind of unaccountable excitement. In the eternally tedious and relentless routine of daily life, their appearance was more of a stimulus than even the variety shows on my computer. "So how can we participate?" All of my colleagues were raring to go.

The artists patiently explained that for this exhibition to be tailored for our city, the first matter of consideration in the creative process would be those incidents of the past that were deeply embedded in our minds.

"Ultimately, the work we want to achieve lies deep within you. This exhibition will be made for all the people of this city, so we hope you can provide us with your most treasured objects that reflect the most precious moments in your lives."

At first, my mind was a blank as to what could be my most treasured moment. This was a question one never encounters in this chaotic second-city life. But my thinking soon opened up, switched on: I recalled the fervent declamations of my first time in court, as well as the vintage radio my grandmother left me when she died.

"Here is the info for the free courier account specially provided by the post office. If you want to donate one of your treasured objects, you can inform the account holder to come collect it from you and the objects will all appear in the upcoming exhibition."

"Oh yes, please do not forget to sign your name to this paper as it will be used to verify that you have voluntarily donated the object to the exhibition. We really appreciate all your support. We believe this exhibition will belong to everyone who lives here."

They passed copies of the agreement for donating personal effects around the office. From an attorney's perspective the agreement was irreproachable, and I took this professionalism as a good sign. In contrast to the way that anything to do with the city always comes down to connections, or that management always needs the rule of man, professionalism is a sign of a better existence. I gravely signed my name to the agreement form as though it were a pact on my future life.

Now, as everybody was aware, the two artists were hard at work on the exhibition. Nevertheless, a dispute over budgetary limitations arose and as soon as the news of this

broke online, public sentiment flared up, with people criticizing the shortsightedness of the city administration and its complete disregard for culture. While critiquing the adminis- tration, people also began actively donating. Everybody felt that it would be a disgrace for the city and its people if this great vision and manifestation of our aspirations could not be realized.

Ultimately, through the hope and solidarity of the people, the day of the exhibition's unveil- ing arrived. It was held in a desolate park, in the center of which towered a massive structure that resembled a Chinese curio box and was adorned with festive lanterns around it. But, to everyone's surprise, when we approached it, the structure had been sealed off and the words NOT TO BE OPENED UNTIL TWENTY YEARS FROM NOW were written upon it, leaving us only to loiter around outside.

It was then that we noticed the tooth- brushes, wrapped in transparent vinyl and suspended from all of the tree branches in the park. The handles of the toothbrushes were transparent so that they looked like icicles. People began to freely turn them this way and that, yelling out the names of those who owned

them. The toothbrushes had been contributed for the exhibition. In this way, those without anything of special significance could also participate.

At last the mayor made a speech: "We are grateful to these two artists for providing us with such a wonderful exhibition with the profound title, *Gōngdù Museum*.[2] Everybody has participated so enthusiastically over these past days and weeks, and I believe that this museum already belongs to all of us. Through the *Gōngdù Museum*, we will weather adversity together and reclaim the city's glory."

The artists then made a statement: "The reason we call this the *Gōngdù Museum* is because the museum is constituted by objects donated by all citizens, with each object embodying our most treasured connections with family, friends, and lovers; it is a testimony to our communal passage through life together. You could also say it embodies the spirit of this

2. *Gōngdù* (共渡) means to communally pass through a period of time. It is also applicable to periods of hardship and adversity, as in the phrase *gōngdù nánguān*, meaning to weather adversity together. The museum name might also be interpreted as "The Museum of Communal Endurance." (*Trans.*)

city. From now on, the city must keep constant watch over the museum, and the museum will keep watch over the city." They continued: "Imagination is more important than appearance, and the core of the work lies exactly in that feeling of imagining what it is to wait for something to be opened, just as we wait to witness the miraculous growth of a person, just as we wait to witness the marvel of life. The entryway of the work will be opened twenty years from now when we will all reconvene here, waiting, and bring to our lives even greater mindfulness."

Their message was met with unanimous applause. Although somewhat dejected that there was no way to immediately see the objects I had contributed, I felt a touch of warmth thinking that they were now together with those donated from other people, and I sensed that everybody there also shared this feeling.

From then on, I would do a circuit around the *Gōngdù Museum* every day after work, exchanging greetings with others walking there. If it seemed that we had been entrusted with something, it also seemed that we had obtained a better understanding of the artists' intentions.

In the newspaper, W, who rose to fame as an author on the basis of his dream notes, praised the audacity and brilliance of the artwork's concept; in particular, the long-forgotten sense of happiness it brought the citizens. W wrote: "At least now we can dream during the day too."

The situation, however, changed after a massive snowstorm. The snow not only swept the toothbrushes and the tree branches to the ground, but the roof of the museum, which had always looked so magnificent, also collapsed, revealing that the artists had used cheap materials incapable of preserving the building for even one year. A bigger shock came after the engineers opened the lock and discovered that the interior was empty. The rumors about what happened were quickly confirmed online: the real content of the work — the precious objects of the citizens — had been sold off for an inordinate sum to a French magnate at an auction in Europe.

But for the grace of God! If not for this once-in-a-generation snowstorm, we would probably still be in the dark. I began to drink heavily. During those endless winter nights, the cheap erguotou[3] eased the pain of losing the

things my grandmother had passed on to me, but there was no way to extinguish that irredeemable remorse: those gifts of life, gifts that had been so dear to us in enduring life's hardships, had been lost forever. Our spirit—the city's spirit—had been legally stolen.

I angrily ripped the agreement to shreds. But I will always remember the artwork that so thoroughly destroyed and humiliated the people of this city, as well as the names of those two artists: Li Zhixing and Huang Xiaojun.[4]

Translated by Andrew Maerkle

3. A Chinese spirit made from sorghum, comparable to vodka. (*Trans.*)

4. Both artist names represent the generation born in the 1960s and '70s, and are reflective of the social ideology of the time. Li is a common surname; *Zhìxīng* connotes "intent on prosperity, aspiring to wealth." Huang is also a common surname; *Xiǎojūn* connotes "small army." (*Trans.*)

Volume 2

The Secret Disciples of Confucius

Her black hair was shiny in the sunlight, and her silhouette beneath the tree seemed to place her in a carefree era. As I walked along the softly gleaming granite on the road, I looked at her as I passed her by. I realized that her face was streaked with tears and her voice shook as she uttered, "I should've gone back earlier, even if it was just one day earlier." She tried her best to keep her composure. When I told Sensei of this, he said gently, "Your heart was moved," before falling back into a long, deep silence. That same day, as I went through the dark passageway, it felt as if everything that had happened outside took place a long, long time ago. I became aware how desolate the world is.

Often, when you reach the end of darkness, immersed within your inner world, you are unwilling to be affected by the light. As you retrace your path, like I did again and again, and as space folds into itself endlessly, time becomes its own black hole: it sucks

everything in and will no longer reveal any secrets of this world.

There is a material energy that surrounds us. We can feel it, but cannot see it. Sensei said, "Note: in the next minute, you will become another you, and your body will transpose itself onto the body of another you." Sensei would guide us to use our senses. This required a lot of practice; we could bear some of these tasks, but not all of them.

Imagine: the world outside is filled with sky-scrapers; large glass walls glimmer with color. Yet we still live in a traditional courtyard. Every day we draw water from a well, collect firewood, cook, drink, study, walk, sleep. Throughout this process, the undercurrents of our inner beings are not discussed. Sensei said, "Since there is nothing to disturb you, why should you make trouble for others?" It was as if he was suggesting that the current serenity is not easily attained; only by treasuring it would we avoid a future of unrest and disharmony.

In that dark passageway I could feel my body walking slowly ahead of me; my inner being was simply drifting above without sensa-tion or knowledge. Cautiously, I made my way through that long passage linking the bedroom

and the training ground. Sensei had deliber-
ately retained its dark atmosphere: "If your
inner being has light, you would naturally not
find it dark." As always, I slowed down my pace
and focused on the sensation of my foot slowly
meeting the ground — from my heel to the
arch of the foot, to the sole, and to my toes.
Tranquility permeated the space and I could
hear my own breathing.

When you enter this narrow passageway,
you feel overwhelmed by the whole atmosphere.
You sense that you might meet a dead end at
any time. However, as you gradually start
to relax and ignore any distractions emerging
in your heart, your body will instinctively avoid
any obstacles in your path, and your steps will
take you in the direction you are meant to go.
The passageway extends without an endpoint:
it seems to adjust its direction for you. Up,
down, left, right, front, behind — none of these
positions is visible any longer in the darkness.
As you move ahead, you feel at the same time
like you are going backward. This passageway
trains us to not only follow directions, but to
listen to the inner voice that leads us.

In this darkness, it doesn't matter if my eyes
are open or closed. I just walk in a random

direction. I walk and continue to walk. When Sensei had sacrificed his own life so that I could survive, I was not sure if I was worthy. It felt like I was in the spotlight, compelled to undertake a mission. I used to desire nothing more than to live a placid life. Yet Sensei wanted us to go in search of something, even though he didn't tell us what we were searching for. Now as I contemplate this, I realize that Sensei left me in a state of utter confusion: I see freedom in front of me yet have nowhere to go.

When I felt the scorching heat on my eyelids, I opened my eyes. I was surrounded by crowds of people and thrust forward. Although their faces retained a youthful naïveté, their eyes revealed a shared anxiety. Everyone was perspiring under the afternoon sun. We kept silent as we rushed forward. I was thirsty and I felt as if I was going to suffer from heatstroke. The dense wave of bodies surrounding me held me up so that I would not fall, and this same force ensured that no one fell. Whether it was a case of everyone helping one another or mutual competition, we finally made it to the only gateway.

Yes, stop here. I should go back. I want to go back. This gateway could be an ambush —

a secret reef. However, from the expressions on other people's faces, I realized that everyone seemed relieved as if they had finally reached the other side and could now see hope. These opposing reactions filled me with hesitation — as if affected by my sentiment, the people began to sway from left to right, causing some of them to be thrown away from the gate. They hollered in fury, "You ungrateful people!" As the swaying became increasingly violent, only those who kept their balance managed to stay where they were. Out of luck or misfortune, or perhaps because I did not use any force of my own, I was pushed very close to the gateway.

There was a steel defense that was kept shut, and that made me heave a sigh of relief. I thought to myself, perhaps all of this will end just like this and everyone will return to where they came from. However, as I started to turn back, I was blocked from behind. People bellowed angrily, "You idiot, do you know how late it is?" A curly-haired guy wearing glasses grabbed me and shook my shoulders. As I was struggling to break free, the grill opened. A hush fell over the scene like a cacophony of voices during an intermission in the theater

that subsides the moment the curtains are drawn open again.

I could see clearly that I was in a massive stadium with lavish fittings. It looked like a Chinese copy of the Colosseum in ancient Rome. Our feet were stepping on the redbrick racetracks as we moved toward the steel gates at the entrance of the arena. Slowly, the gates opened. There was an extravagant clattering of metal and it seemed that the beautiful, ideal world everyone longed for was right behind the gates. The only thing I could do was to close my eyes as the sound pierced my ears. I felt myself being carried by the human current and drifted upward, upward.

When I finally fall, I might descend into a cool midnight in early summer. I will still find bold, heroic-like questions waiting for answers, and through them, I will take another step toward exploring the labyrinth of life.

Test (please indicate "X" next to your selection)

It is a cool midnight in early summer, well
suited for an earlier slumber. Imagine
you are the story's protagonist. Select how
you would like your dream to develop:

1. In your dream, you are a very popular
 pop star! In fact, you have a secret—you are
 currently romantically involved with a
 young, successful (male or female) singer.
 This situation is considered taboo for two
 pop idols. Will you:
 O Retire from the pop scene to focus on your
 relationship with him or her.
 O Give up on the love affair and continue to
 be a singer.

2. The scene changes. You are now sitting an
 exam for the diplomatic service. You choose
 to be posted abroad. Which country do you
 hope to go to?
 O Australia, with its wide expanse of land-
 scape.
 O Italy, with its rich art scene and ancient
 ruins.

3. This time, you are an administrator for an advertising company. One of the company's clients is going to launch a healthy new beverage. What would you call it?
 - ○ Vitality Vitamin A
 - ○ Beautiful C Component

4. You become the secretary for a director in a large firm. Although he is not particularly friendly, the director is rather concerned about you. You have discovered that the other directors in the company are planning to force your boss to step down. Now that you know the truth, what will you do?
 - ○ Feel sorry for your director and tell him about the plan immediately.
 - ○ Since he is so fierce, you will not let on about the plan.

5. Now, you are the deputy of the National People's Congress. A few of the members hope that you can build a golf course to boost the tourism industry. However, doing so could increase pollution from pesticides. You are stuck between a rock and a hard place, so what will you do?

○ For the sake of the environment, you refuse to build the golf course.
○ To help resolve the current economic problem by boosting tourism, you will make the golf course a reality.

6. This time, you are an enthusiastic new film director. What is the theme of your first film?
○ A romantic love story.
○ An imaginative science-fiction story.

7. Now, you are an astronaut being sent to Mars to fulfill your mission with a companion. What are your concerns for this particular mission?
○ You are concerned that you will have to eat the rather bland foodstuff made for space.
○ You are worried that you may not return to the planet Earth that you love.

This test indicates the career path that you are most suited for. By discovering what career is best, you will be able to develop your talents.

Hence, after passing through the metal defense and walking on the grass in the early summer night, two young men dressed in navy-blue suits took me to a "place where dreams come true"—to the Century's Talent Expo. This was the place where everyone was fighting to get into because it was filled with opportunities for the future. It was only after they arrived that people realized this place was a previous disaster site, creatively developed based on its geographical conditions. It was constructed on a depressed part of the landscape that was created by a mudslide and an earthquake. After working tirelessly night and day, covering the land with Astroturf, the landscape architects constructed a theatrical-looking place. In particular, when the lights are cast on the spectacular man-made landscape at night, the whole atmosphere is especially stirring.

The construction of the Century's Talent Expo on the disaster site came together to form the city's largest real estate project in its history. The expo stood out from other exhibitions in that it did not impose strict criteria on those participating and included professionals such as psychiatric therapists, food nutritionists, glaziers, parkours, recycling-data experts,

magicians, plastic surgeons, dictionary editors, bloggers, LED technicians, hungry artists, palm readers, gardeners, etc. All of this was done in a bid to hold the grandest gathering in the country's history where talents are both attracted and delegated.

When the disaster took place, I remember we were uncertain if we should help with the rescue effort or not. All of the students were talking about it, asking Sensei what to do. Sensei just smiled, letting us wander around in circles until we were dizzy and unable to stand up. Whichever way we fell to the ground meant that this was the direction we would go to assist with the emergency rescue. I fell to the east. I moved eastward, through the city, before finally arriving here.

There was no panic among those facing the disaster. Instead, a rare sense of harmony permeated the city. There must have been something or other supporting the thousands of people from this city as they diligently made their journeys on the road. I am destined to vanish within the crowds of people living here. Since my life was saved, I have no reason to be afraid of losing it again. I must do my best to make my way forward in this gray and dim city

as I gradually release the burden of my flesh. The days when my heart's desires coincide with the boundaries of what is right are near.[1]

I thought of how those who had been unemployed for a long time may well find love among the ruins.

Translated by Melissa Lim

1. This is a reference to the second chapter in *The Analects of Confucius* where Confucius said: "When I am fifteen, I aspired to learn. At thirty, I can be independent. At forty, I am not deluded. At fifty, I knew my destiny. At sixty, I knew truth in all I heard. At seventy, I could follow my heart's desire which coincides within the boundaries of what is right."

Volume 3

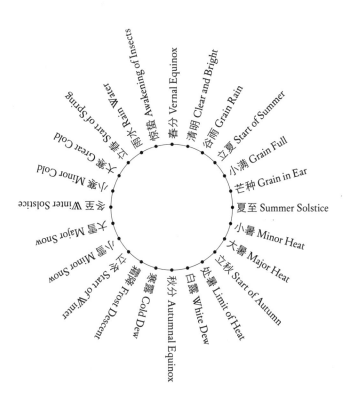

春分 Vernal Equinox
惊蛰 Awakening of Insects
雨水 Rain Water
立春 Start of Spring
大寒 Great Cold
小寒 Minor Cold
冬至 Winter Solstice
大雪 Major Snow
小雪 Minor Snow
立冬 Start of Winter
霜降 Frost Descent
寒露 Cold Dew
秋分 Autumnal Equinox
白露 White Dew
处暑 Limit of Heat
立秋 Start of Autumn
大暑 Major Heat
小暑 Minor Heat
夏至 Summer Solstice
芒种 Grain in Ear
小满 Grain Full
立夏 Start of Summer
谷雨 Grain Rain
清明 Clear and Bright

Dear Navigator

立春 Lìchūn: Start of Spring
The cat is too clean to want to be human.

Dear Navigator,
I don't know your real name, but I'm sure
"Navigator" is an appropriate substitute that
both reflects the place where I hold you in my
heart and conveys the respect I've silently
maintained for you these many years. If you
permit, I'd like to continue addressing you by
this name. Actually, I hear we're almost the
same age, and this makes me all the more eager
for us to share a sustained correspondence.

Allow me to introduce myself. My name is
Xie Delin. My parents met working for the
Party in the Soviet Union, and when I was born
they gave me what was then a popular Soviet
name, Vladimir Ilyich Xie Delin.

At the time, the Soviet Union was known as
"Soviet elder brother." My parents diligently
studied Russian, because it was the key to

unlocking the future of international communism. But quite soon China ushered in an anti-revisionist movement, and to avoid sabotaging my prospects, there was no more mention of my Soviet name. I still remember the melancholy and plaintive Soviet folk songs my mother would softly sing to herself at night. It's possible to find even more details about my parents' story in the archives of the Chinese Communist Party, and the reason I mention this is because I've recently resurrected my formerly short-lived Soviet name, which is directly related to the experimental project in which I am now involved.

You've probably already heard about the spaceflight research facility on the outskirts of Moscow where six volunteers from Russia, Italy, France, and China will enter into an isolation module and embark on a 520-day simulated space mission to Mars; of the six volunteers, I am indeed the one from China. One of the objectives of this experiment is to gauge whether humans can physiologically and psychologically endure the round-trip journey from Earth to Mars. If everything goes well, we will arrive on the 250th day, and possibly even have time to walk around outside, before

using the remaining 240 days for the return.

I never doubted the incredible significance of this mission for humanity. Not only is this what motivated me to participate in the experiment, but it's also my primary reason for accepting any challenges that arise in the course of it. But I still faintly sense something that, for reasons I can't articulate, perturbs me, makes me distracted and restless, gives me the foreboding sense that what I am going to confront is exactly the same predicament from which I am escaping. I'm even afraid that at a certain moment during the journey I could fall into an eternal state of vertigo.

I really had to think it over before deciding to write you. I sense a connection between us. I sense that it is only this intimate dialogue between us that can truly help me pass the coming days of extreme loneliness and tedium. I have knowingly risked violating the nondisclosure agreement in order to write you, but I have no alternative. Only our connection can save me from mental chaos.

Though the city before me is somber and ashen, the spring has come. Excited youths walk along the streets, revealing hardened smiles from amid the dense fog. If you are open,

I believe you will support me in my prepara-
tions for embarking on this odyssey.

Vladimir Xie, February 5

雨水 Yǔshuǐ: Rain Water
Behind every door I open, there is only nothing.

Dear Navigator,
The primary task here is to comb through the
historical clues while constantly following
the central axis northward through the uniform
darkness, otherwise I will completely lose my
way. There's a good possibility that this axis
already exists in our pineal glands, although
right now I know nothing of it. The primary
task also includes bidding farewell not only to
my relatives, but also to humanity, before
entering into the one-person isolation module.
They say my activities in the isolation
module will be recorded twenty-four hours a
day, and that I will live entirely under obser-
vation. This is exactly the means for developing
relations with others to which I need to adapt:
an indirect means of contact through video
or some other medium—the hybridization of

democracy and networked society, which fills my heart with a dull pain.

About 3.6 meters wide, twenty meters long, with six tiny sleeping compartments, a living room, a kitchen, a workspace, a toilet, a lab, and a greenhouse—truly an extravagant space, whether considered from the perspective of capital investment or of personal living. It seems that as long as I have the blessing of all humanity, I can consume without a second thought these resources, these lives, along with my own life. I always felt my life had been undervalued, but perhaps it is precisely because of this that I was charged with penetrating certain mysteries of the universe. It looks a little comical, but this mission was actually launched in the name of all seriousness, in the name of political groups and of nations.

Before entering the isolation module, I strained to catch a glimpse of the world outside. Rain was falling from the sky, and the damp cement ground reminded me of some supermarket parking lot, or a listless afternoon during middle school. The materiality of the world is ever so frank, vividly exposed before me, just as the isolation module itself announces, through its precise, flawless

materiality, how humans must adopt extreme measures of artificial control before they're able to realize hyper-materiality and understand nature.

But the real obstacle is that, once you know that no matter the hypothesis, you're still carrying out your experiment in a familiar material environment, you have to confront a kind of split consciousness: you are controlled by the experiment, and are also the one in control. I'm not sure whether all this data monitoring is really about observing me as an individual, or observing my performance as an individual, and perhaps there's no way to even separate the two, and this is an experimental deviation that we simply have to accept. Similarly, I'm entirely unsure whether my perseverance here is for the sake of finding my inner voice, or for the sake of my performance before the instruments.

What I do know is that my career is destined to unfold in a claustrophobic, artificial environment with exaggerated lighting and big-budget effects, in an attempt to capture the attention of an unresponsive box office. Maybe the content of the performance itself and the real issues we are facing have become confused.

Dear Navigator, I feel so deeply that as long as we can maintain our intimate connection, I will be able to find my true reason for seeing things through. And in that last glance before entering the module, I had a premonition: that patch of rainy cement would become a reference for the measurement of my evolution.

Vladimir Xie, February 18

惊蛰 Jīngzhé: Awakening of Insects
If I can decide to buy that pair of shoes, I can also decide whether to live or die.

Dear Navigator,
Everything in this isolation module simulates an actual space capsule; the only thing that could not be simulated is weightlessness, which is about as disappointing as a bride not showing up for her thoroughly planned luxury wedding.

When we try to reinvent ourselves in this world, what we really want to do is cast off gravity; it is only when we float through the air that all daydreams really begin; and now, walking in summer clothes through this

wooden cabin, it's like we're at a resort. I once thought this isolation module could at least be a kind of retreat, but after just a few days, I realized that the tests we have to perform daily will keep us as occupied as office drones.

Every now and then, when I want to do a test on brain circuitry, I put on my hat (it's actually covered with a mesh of electrode wires), and once the foam on the crown has absorbed the saline solution — growing abnormally heavy and settling tightly on my head — electrical currents begin to prick my nerves. For the better part of each day I am glued to the readout monitors, responding to all kinds of test protocols flashing across the screen, while constantly receiving photoelectric prompts that force me to react rapidly.

Most of the time, I feel that instead of being about science, these tests are just a puerile way to kill time. Only in the dead of night can I finally extract myself from the grind of this routine, only then can I recall a sense of reality that is not so removed: night in the Moscow suburbs, rain still moistening the birch forests — all I have to do is push open the door of the module and I can fall back to that damp cement ground.

It's not that I'm afraid of true solitude, the deepest solitude, the kind you experience among a group of boisterous people; on the contrary, that kind of unconditional solitude is exactly what enables me to stay here without any regrets.

Dear Navigator, they actually shouldn't keep me so busy. Instead, they should make me so lonely I go mad. That's the only way to truly find the path to Mars. Just as right now, it's only in the dead of night that I can return again to our connection.

Vladimir Xie, March 7

春分 Chūnfēn: Vernal Equinox
Every night I strain to fall asleep, strain until my heart is squeezed with pain.

Dear Navigator,
I constantly wonder what time it is where you are. In day after day of high intensity tests—especially after the frequent photoelectric stimulations and the screen exercises with flashcards—I experience a kind of postorgasmic exhaustion, and then everything becomes

detached, such that I even detect my own bitter smile. In this completely isolated and prophylactic environment, it seems that all impure thoughts must be kept outside, and all unhappiness, all guilt thoroughly eliminated.

Food also aggravates this "sense of purity" that I have: everything we eat is either powder, liquid, or in capsules. The form of the food no longer has any significant material distinction, nor is there any difference, in the biological sense, between meat and vegetables. The only thing indicated on the packaging is the general flavor, for instance, whether it's chicken or beef flavor. The original form of the food appears only as an association in our heads.

Beyond all doubt, the tone of the media is optimistic: these volunteers are enduring a loneliness that would be unbearable for ordinary people; they are throwing themselves into an enterprise that will benefit the future of humanity. Family, friends, lovers; they all exist in the form of a blessing on the other side of the screen, while I wave to them from inside. Usually at this point, shadows of things neglected in the past emerge, just like the trivial incidents that great enterprises never care to mention.

In the contract that we signed for the mission, after all the technical clauses, I wrote down a line of poetry from Tao Yuanming[1] — "What is there to say after death? / Entrust my body to the mountain" — along with the following "testament":

1. If the worst should befall me, please donate my organs to those in need. (This is actually a line my parents once taught me.)

2. Please use the five hundred thousand renminbi that I will receive from this experiment to establish an online foundation for research into and prevention of suicide, to be called "Hua_Sheng_Lai" (花生来).[2]

1. Tao Yuanming lived from 365 to 427 AD. The verse is taken from "Ni Wan'ge Ci San Shou" (Three Poems in Imitation of Coffin Bearers' Songs). (*Trans.*)

2. Evoking the unusual usernames of members of online communities, this name offers multiple interpretations depending on how its characters are grouped: *huā* commonly means "flower," or "to spend," but it has other meanings as well; *shēng*, meaning "to give birth" or "to produce," "existence," "life," "raw"; *lái*, "to come." These can also combine to form other words: *huāshēng* (peanut), and *shēnglái* (by birth, innate). The name thus variously connotes: PeanutComes; Pay_Your_Life; flowersprout; Born Flower; etc. (*Trans.*)

My parents did not live to see the smog over today's Beijing. In the process of committing to the revolution, most of the time they were treated as enemies of the revolution. All the same, they still loved the protagonist in the film adaptation of *The Gadfly*, and it seems that this and other literary images helped maintain their faith in the enterprise of Communism; these ideals also became bizarrely mixed up with that fable by Tao Yuanming of which they were so fond, "Peach Blossom Spring."[3]

If the smog over today's Beijing came about in exchange for the blood of the revolution, then, dear Navigator, how should we understand the once and current space race, as well as this journey to Mars? Are we in the process of completing the unfinished enterprise of Communism?

Vladimir Xie, March 20

3. In the fable, written in 421 AD, a fisherman discovers a utopian community that has remained hidden from the world for centuries after its members' forebears fled from civil unrest during the Qin Dynasty (BC 221–206). (*Trans.*)

清明 Qīngmíng: Clear and Bright
*Somehow I'm always a half-beat slower than
others; every time I want to say something, they've
already turned away.*

Dear Navigator,
Received on Earth after a twenty-minute time
delay, the communications I send from here
function like a time machine. For some reason,
about which I'm no longer clear, when I push
the key and the microwave data is sent off, a
dull pain spreads from my fingertips through
my entire body.

Those twenty minutes allow me to slowly
enter a void of memory, to return to a long
sealed-off building where for a long time I
had no idea I was the only liaison between a
certain group of things; a time when I had been
settled for so long in that building, which
resembled this module, that I lost track of time.
I remember I still paid monthly rent, and could
still recognize my room number in the corridor
filling up with dust. Sometimes I even got
the feeling that everyone in the building had
already moved out and I was the only person
living there, like some holdout waiting for
compensation.

Looking out through the dust-coated porthole window, the city was eternally ash colored, yet I could still make out the Imperial Garden and the Zhúbō fish market off in the distance[4]—the only landmarks I could trust for gauging reality: the cycles of the plant life in the garden brought me news of the changing seasons, while the size of the crowds in the fish market told me how the economy was doing.

I was already used to that viscous, ashen mist filtering through the edges of the window, flowing into the room and dispersing there, gradually encroaching upon my windpipe, lungs, and entire body, until at a certain point the mist would make me dizzy all over, and then produce a fleeting ecstasy, which would release me from "thinking."

When I tried to stand, I would end up tumbling lightly to the bed, and then, escaping Earth's gravity, drift through the window and beyond, where, striding across the planet's surface, all humanity was so hurried and full

4. Zhúbō is a fictional name inspired by the famous fish market in Tokyo, Tsukiji (筑地 in simplified Chinese). The first character *zhú* means "to build" or "to construct," having architectural connotations; *bō* is the character for "waves." (*Trans.*)

of confidence.

I was twenty-four that year, an awkward-looking but dreamy programmer at a company called New Star, spending whole days camped in front of the computer developing a software called "PP Time Machine," which captivated me, and also showcased my abilities, so that I became the driving force behind the project.

It was also there, in the midst of the cloud-computing boom, where our fates first intersected. That was the beginning of our acquaintance.

OK, I have to do another test, must stop here for today.

Chat later!

Vladimir Xie, April 6

谷雨 Gǔyǔ: Grain Rain
To celebrate my birthday, I bought clothes online without even checking the prices.

Dear Navigator,
I noticed the girl named Hua_Sheng_Lai one day when we were doing back-end monitoring of the PP Time Machine's user rate. Her name

leaped off the screen, her data revealing that she liked to use Time Machine's delay function to schedule the release of her Weibo messages, as though she enjoyed playing temporal games of hide-and-seek with everybody.

I took a liking to her Weibo feed, its brightness, humor, narcissism, self-deprecation:

> *I feel sorry for the time, because it cannot kill itself. If there's time before I die, I'd definitely wash my socks, get that feeling like in TV ads of being so fresh people can't help sniffing. It's pretty good to be an insect, because you'll die before this world can make you melancholy.*

I fell a little in love with her.

At the time, across the whole company and around the clock, everybody was working on perfecting Time Machine's functionality, especially me. As the person in charge of its development, I dreamed that PP Time Machine would become a breakout product, proving my brilliance. At the time, my only diversion each day was to read her Weibo. Checking out how she was using PP Time Machine was also without a doubt the most exquisite task of all when it came to the product.

In those days of round-the-clock, intense work, which were also the days when everybody was captivated by Time Machine, it seemed as though we could skip forward and rewind time like a tape player. In the days leading up to that fateful day, we were immersed in an almost festive atmosphere.

If only I had noticed your signs then, maybe I would have fewer regrets now. Maybe I could fly untroubled into that pure, starry space. But in reality, I have set out on this long and winding journey, which will truly, profoundly allow me to understand your teaching, and accept the turbulence of time, wherein the order of things is upended, wherein we meet again what has already passed.

<div align="right">Vladimir Xie, April 19</div>

立夏 Lìxià: Start of Summer
If you truly like me, why can't I put my hands on you?

Dear Navigator,
The isolation module has an air of sadness. Every day upon waking I take a sample of my

urine, which always makes me wonder whether I'm not in the sterilization unit of a hospital.

And I'm always so eager to see that red-haired girl on the monitor — Ophelia, the Austrian mental-health specialist who records my facial expressions in a dossier every day, while I, too, inspect her facial expressions through the monitor. She is the only link we have to the outside world, and the only member of the opposite sex we get to see every day. Frankly speaking, my desire to see her is just like my desire to confide in you.

It's strange how even though I spend every day with my comrades, they seem to be nothing more than my avatars and shadows; I have no sense that they are any more substantial than the images on the monitor. Perhaps because we're all so professional, we get along the way that professionals are supposed to in civilized society, each with his own responsibilities. Probably because we're all under pressure from the outside, a collective mentality exists among us, such that there is none of the friction that occurs in ordinary interactions.

However, among the six of us there have emerged two different convictions, neither of which is capable of swaying the other: one

group believes we're actually on a space mission to Mars, while the other believes we're only conducting an experiment inside a ground-based isolation module. For those who believe the former, time is spent worrying over whether everything is proceeding normally with the flight, time exists in a state of tension, and accordingly is relatively active; while those who believe the latter are just as actively engaged in killing endless time.

The only consensus is: we ultimately have to leave Earth in order to appreciate all the small gifts it provides us.

Dear Navigator, I must maintain this intimate connection with you—just like how on a retreat one must maintain the central axis in one's head—so that in this endless inter-stellar journey I do not lose my bearing.

I will hold your hand!

Vladimir Xie, May 5

小满 Xiǎomǎn: Grain Full
In my moment of confusion, I breezed through the next minute. It's time for bed.

Dear Navigator,
My brain has swollen, like in oxygen depri-
vation. Have the summer winds already blown
across Kunming Lake, are the pigeon calls
already spiraling in the air above the drum
tower?

In any case, in this process I must accept
how, under the gaze of the media, I have let my
body become a tool for export and import,
for probing, at the intersections of different
times, the possibility of humanity extending its
longevity. Under general conditions on Earth,
this would be related to religious experience,
but I am using an interstellar voyage to verify
the possibility. In the process of approaching
light speed, my time will slow to that of myth,
suspended somewhere, just as reality can
be preserved indefinitely in people's memories,
where we can connect with time that has
already passed.

Such as that day Hua_Sheng_Lai casually
wrote on Weibo:

> *Been dealing with depression so long, I've got
> to give myself a break. Don't feel sad about my
> going. Bye-bye.*

A chill rushed down my spine, and I immediately experienced a strange exhilaration, like when a beast springs out at you from some dark recess. It rapidly engulfed me. Then a voice told me: the moment you have been dreaming of has arrived. PP Time Machine will become the center of everybody's attention. I could not bear the double shock that this inflicted on me, and I turned to the company for help, but the managers demanded that we maintain our composure and not leap into reckless action.

By then, posts of consolation from the online community had already flooded her Weibo thread, and someone contacted the local authorities. Her body was discovered in the women's dormitory. One end of a colored nylon rope was tied to the upper bunk, the other tied around her neck. She committed suicide in the same place where she liked to log into her computer, only her computer was switched off when they found her body. Her parting Weibo message had been posted using Time Machine's delay function.

Dear Navigator, how can I describe to you the feeling I had then, the mix of terror and excitement that follows the loss of innocence?

Because of Hua_Sheng_Lai's suicide, PP

Time Machine garnered the popular recognition I'd been dreaming about. Schooled in crisis management, the company publicly apologized for the unforeseeable tragedy, while critics angrily denounced the company. As later market surveys confirmed, PP Time Machine gained users from the ordeal.

"Nobody was at fault. Nobody could have ever imagined that PP Time Machine's delay function would bring about this tragedy."

The psychiatric counselor hired by the company continued, "Moreover, since the incident, PP Time Machine has been updated with an information monitoring system, which we believe will effectively watch out for this kind of situation in the future."

In truth, I was powerless to make any decisions or exert control over anything. With my colleagues looking at me enviously, I was transferred to a top-secret department, with twice the salary and twice the responsibility.

Dear Navigator, what I want to say is, if I didn't have your guidance and protection, I'd probably be eternally, apathetically repeating the same injury against the innocent.

Vladimir Xie, May 20

芒种 Mángzhòng: Grain in Ear
*How I long to talk up the good things in this world,
since it's all my fault.*

Dear Navigator,
Hua_Sheng_Lai's Weibo account is still
online, forever frozen on her last message.
Everything she wrote, the cloud maintains for
her, as if she'd only left temporarily to attend to
something. I wouldn't be astonished if some
new content appeared on her feed one day, for
it's far easier to extend one's life in the cloud
world than in the real world.

In the real world, there are too many
encounters that stir our emotions. Once, when
I was sitting by the door of a snack shop, facing
out onto the street, the boiled tea eggs still
steaming, the street light across from me
seemed to become a studio stage light and the
movements of the passersby took on special
significance, such that you could almost guess
each person's story, each person's preoccupa-
tions.

Later, near to where I was sitting eating up
piping-hot noodles, there came the clear, sharp
sound of keystrokes from the ATM. How does
time compensate one's sorrows? All your

friends, your mother (the mother you said on Weibo that you loved and hated), how will they bear this pain? When I glimpse a girl on the street in a miniskirt, I think of you.

Enveloped in countless dark nights, I sense in the dimness a certain kind of impulse that comes from dark matter. If you stay still and quiet, you can sense the impulses generated by invisible material.

My parents believed that martyr's blood could be exchanged for today's blissful living, and their energy shaped the future and afterlife for which they hoped. But we have already been dispersed from the powers of the collective, atomized into scattered and aimless particles, returned to chaos.

As such, dear Navigator, however much I need the delicate impulses of your dark void, they unthinkingly, and incrementally, propel me along the trajectory of fate.

Vladimir Xie, June 7

夏至 Xiàzhì: Summer Solstice
Even when I wake up, I tell myself to go back to sleep, because after all there's nobody waiting for me.

Dear Navigator,
Because of Hua_Sheng_Lai's suicide, I was transferred to New Star's top-secret M500 software engineering section, which I later learned was the branch developing software for the Mars project.

Unpredictable and fantastical events often prove to be a part of the world's normal process, like the way the Mars project originated from an audacious vision: all the world's investors should get together to develop extraterrestrial property. And I, just an insignificant speck swept along in all this — what I end up colliding with depends on fate.

Just think about it. The lives of my parents' generation were almost entirely cut off from the cloud world. Their lives exist in my head or in the files of the party archives, but they are outside of the cloud world that, today, is shared by all. The cloud world — I can't think of a more reassuring way to extend life.

I also forgot to tell you about my dreams, which are becoming an ever more vivid part of

my waking life. After spending the whole day as a test subject, I fall into a deep depression. I become indifferent to everything around me, and usually it's on these nights that my dreams appear incredibly real.

I dreamed my earwax bloomed like coral.

I dreamed of mountains and valleys, which seemed to have once been the site of fierce guerilla fighting, and forests, which once harbored the soldiers, and wild fruits, which once moistened the soldiers' cracked lips. But then what appeared before me was an ecological park built for tourists, with mountaintop villas and swimming pools.

As I dream, I suddenly feel I have been here before, so familiar are the roads, the terrain, the ridges of the mountains, the plant life. Breathing in the fresh air, gazing into the distance from the mountainside, the agony of the first time I was shot dead abruptly comes to mind: seeing myself fallen there, bleeding profusely, life index rapidly falling, completely paralyzed, helplessly watching myself go. Yes, my comrades and I have already rehearsed this war hundreds of thousands of times in our hyper-simulation computer games, learning how to adapt to local conditions, how to guard

ourselves—so it is no surprise that each blade of grass and each tree feels familiar, even elicits a queer sense of intimacy and excitement.

Frightfully lonely here, with only a faint breeze rustling the treetops, the landscape is so beautiful that it could hardly have anything to do with war. This gives me a supernatural sense of relaxation. Reality will quickly prove that this war is anything but a fiction, that the imagined enemies will not appear as they did in the computer game, that the feverish anticipation my comrades and I felt for their appearance was only for the sake of validating, should any of us get hit, that the blood we spill and the bodily pain we suffer will be equal to that of our enemies.

There is no need for me to imagine dying anymore—compared to sitting in front of the computer and imagining over and over the agony of getting wounded and dying, to be killed in action here would perhaps be liberating.

Liberation.

I dreamed that before I left this room, the ground was already crawling with insects, everything falling apart, walls flaking. It was amazing how rapidly it deteriorated, but now I am moving to another place, where the

ringing of Sunday church bells can be heard in the distance.

Dear Navigator, I urgently need the tolling of church bells, or temple bells, to feel the blessings of the masses.

Vladimir Xie, June 21

小暑 Xiǎoshǔ: Minor Heat
In the entire galaxy, my existence amounts to nothing more than the addition of a minor blemish to the Pisces constellation.

Dear Navigator,
I don't know whether the six pills I swallow every day are actually necessary for replenishing vitamins and nutrients and fatty acids and other trace elements, or whether they're just placebos.

My colleagues have begun to hold heated discussions about food, although usually when their visions of a certain delicacy reach a climax, they abruptly stop. As for our three crewmates from Russia, there is an additional topic of discussion — vodka — that always ends in an argument.

As though meant to test our mid-flight emergency response capacity, yesterday there was a blackout in the module: everything went pitch-dark, followed by the ventilation system shutting down, and soon I had difficulty breathing. Then came a message from the crew commander asking everybody to remain calm.

I thought of the first time I went diving and the terror I felt when the instructor let go of my hand. Confronted by the vast ocean floor, I seemingly returned to the chaotic, boundless beginning of the world, completely losing my sense of time and space, the sound of my breath amplified like a voice tearing through my body. The slightest slip in attention would send me plunging into another world—perhaps this is the near-death experience of which people always speak. The space module could also be this kind of place.

Every time I leave, it always looks easy but it's actually hard—there's too much anxiety. In dismal weather, a middle-aged woman carries a plastic bag filled with vegetables, while the people getting off work for the day pour into the bus, signs of depression blackening the lights of the city. The thick of family life is near

at hand, as the plump body of a young house-
wife (wearing pink see-through nightclothes)
slowly vanishes from the street corner. I recall
your childhood: "What a good and gentle
person you are!"

Tell me, when does love and hate become so
intensely entangled that people feel they have
to kill themselves in order to escape it all?
The after-hours career women are still wearing
their suit skirts and red heels, the food vendors
are already ablaze, the striped lamps of the
salons are turning, and I feel like vomiting,
but then I think of you and feel better—I even
feel the happiness in this world of chaos, so
intoxicated I don't want to move another step.

When those blinding lights switched back
on, I surfaced drenched in sweat, the monitor
before me coming back to life, the ventilation
system letting out a roar, everything running
again. Calmly fixing the breakdown in the
spacecraft simulator's power system, the crew
commander had saved our lives.

That fire burning in some dark corner
below the overpass—in the post-rain twilight,
its outline appeared incredibly sharp, leaping
into sight.

Dear Navigator, I've finally smelled those wafts of incense.

Vladimir Xie, July 8

大暑 Dàshǔ: Major Heat
If I believe in life after death, then I should be able to understand why the people I love must also die.

Dear Navigator,
Aviation is the same as seafaring: it's the science of getting lost. One of our most important tasks each day is to check the heading and flight coordinates, to avoid getting off course. Although I don't know where we are, my sense of direction is still pretty functional, only I have the vague sense that time has slowed for me. In infinite space, the vacuum enclosing the isolation module seems to have buffered time. Since life inside the module is shielded from the complicated outer world, it's as though my relationship to time has also become purer, and therefore time has slowed.

Fundamentally, is there any absolute difference between somebody sitting in prison and me sitting in this isolation module? Having

once been tempered by the earthly world, and now being put in this isolated environment for tempering, everything inside the module has taken on a strange sense of freedom. In my parents' time, prison was a national apparatus that had to be destroyed, and they willfully smashed its concrete walls. In restricting the scope of physical activity, prison actually stimulated the free will of the people it contained, while the physical suffering of their bodies only hardened their conviction in the revolution and the future. But what I'm seeking is not some superficial equilibrium between good and evil that can be obtained from already existing national apparatuses. What is important is how to transform punishment into creativity through self-reflection: if prison and the isolation module flying to Mars both use the restriction of freedom as a means of arriving at sublimation and the completion of a more ambitious calling, then the ruminations of the people in prison and my own ruminations in this isolation module should both lead us to a new consciousness of the misfortunes of the past.

Dear Navigator, I think you will agree that ultimately being banished here is in fact my good fortune.

Vladimir Xie, July 22

立秋 Lìqīu: Start of Autumn
The sight of her turning around is as beautiful as someone suffering from melancholy.

Dear Navigator,
She once helped me make the bed. During an exhausting, tense journey, what could be more generous than a glass of water, a bowl of rice, and a bed in the midst of hunger and thirst?

By the quiet light of the table lamp, the sight of her making the bed was unforgettable: taking clean sheets from the cabinet, she contemplatively adjusted their position on the bed, occasionally stepping back to look, as though viewing a painting. Seeing her absorbed in this way made me ashamed of my wickedness.

The table lamp illuminated her silhouette, her black hair swaying with her movements around the bed, as though in some quotidian dance. Enveloped in the stillness of the room

and the fragrance of the freshly dried sheets, there was an urge to die right then and there.

Gazing out the window of this lonely room, one could always see the church steeple. In the evenings, when the lights went out indoors, the far-off church, lit from below by floodlights, would float out of the darkness, tantalizingly within reach.

A lamp, a song, a bedsheet — each can give this completely characterless, isolated space an air of inhabitation. In the Chinese view of the universe, although humans are not its center, neither have they been ruthlessly expelled to its margins. What makes humans human is precisely that, as the part of nature that is full of sympathy, they mutually complete the other things that exist in this world. Even if Hua_ Sheng_Lai's mortal body no longer exists, she still has merged with my life; even if my colleagues appear to be sleepwalking apparitions, they still share with me their cravings for good food and their thoughts of home.

Our feelings are necessarily connected to everything that happens in the universe, only the reactions carried by those ripples spread at differing frequencies. For example, when we heard the news about Steve Jobs's death, it was

like learning of an incident from another planet. Separated by a fixed distance, there are certain things that are hard to feel sad about, and others to which I'm even more sensitive.

As for myself, the entertainment programs on my desktop are superfluous, as I prefer to reap in quiet the remorse brought by the slowing of time. More than once I have recalled how, behind Hua_Sheng_Lai's outwardly happy-go-lucky personality, there was a kind of self-destructive urge, while I am the opposite, in that I would never be willing to destroy my one and only hope. I would turn her death drive into my lust for life.

Is there anything better suited for meditation and penitence than this journey to Mars?

Vladimir Xie, August 7

处暑 Chǔshǔ: Limit of Heat
In everything I do, I always work to avoid results, avoid beginnings and endings.

Dear Navigator,
Some days later, I discover that I am working with *time bandits*, that I myself am one of them,

making off with other people's time, while my own time is stolen without my realizing.

Shares, futures, banks: the time bandits sell watches to those without time, and after they've bought their watches, these people believe they actually possess time. Nor is there anyone who can stop the time bandits; even this isolation module flying to Mars cannot prevent them from consuming our lives in advance, because it is they who are the backers of the Mars project.

Just as an idealist and sadist are only one step removed, the time bandits have used humanity's desire for immortality to steal the time necessary for eternal life.

Perhaps under the influence of my father, I feel the only thing distinguishing me from the time bandits is that I have no care for my physical body, bravely going to further extremes in testing the limits of humanity, becoming a secret liaison for contradictory forces. I only want to experience extreme acceleration in flight, accelerating to the point of lightspeed, where our biological clocks slow down and we can head toward the opposite side of materiality.

This is a form of atonement, yet also a kind of pretension, since I won't experience any

fundamental change and there's no way I could become a humble penitent. Anyone living in this world has his or her own rationale. If divinity could be shared out at every moment of every hour, then it could be a corporation, school, or church, take any form at all, which ultimately is only a support — "Moonlight plays before my bed, / Could it be frost upon the ground?"[5] — but as long as it can be shared, then it is divine.

Dear Navigator, please excuse me, my remaining pride keeps me rattling on at you, and sometimes I end up not making any sense … I am so thankful for your generosity.

<div align="right">Vladimir Xie, August 24</div>

5. A famous verse from the poem "Jing Ye Si" ("Thoughts on a Still Night") by the Tang dynasty poet Li Bai (701–62 AD). The complete poem is as follows:
Moonlight plays before my bed,
Could it be frost upon the ground?
Head raised, I gaze into the moonlight,
Lowered now, remember home.
(*Trans.*)

白露 Báilù: White Dew
Being with the elderly, reining in arrogance and rashness, you can live cleanly.

Dear Navigator,

Through the windows of the spacecraft, I can almost see that massive diamond floating in the air — is this the ring that promises humanity and stars to one another? Crystallized time, diamonds are the polar opposite of humanity's attempts to steal time, condensing time, concentrating destiny. We are all children of stardust, perhaps originating from some explosion that happened in the remote past, as it is precisely the remnants of stardust that produced life. Our real mother already dead, we are all residues, our hearts burning as fiercely as the massive thermonuclear core of the sun, although necessarily under the cover of strangely cold exteriors, until the fires inside burn to exhaustion and slowly go cold.

After its hydrogen is consumed, a star dies, growing colder, with the entire space around it returning to blackness. The age of stars will end, while dark matter continues expanding. When the galaxy dies, we will arrive at the winter of the universe.

Consciousness of time is what allows us to survey the past. If we lived long enough, we could see far enough — much further into the past than now — not like the fleeting span of our current temporal consciousness.

If we lived long enough, perhaps until 110,000 years from now, we could reach the next closest star to us, Proxima Centauri, but the cruel part is: subjective morals do not determine what gets to survive — this is a pitched battle, and those that survive are those with relatively durable stores of energy, but this also entails gradual stabilization and death. If its own density is too great, then a star must simultaneously generate its own dynamic force while forming external relationships, repeatedly settling and then moving again in chaos.

If the planet's core is dead water, then there's no way for it to gain energy, because energy can only be gained and converted in reciprocal motion. This is like the way people obtain the means for inner peace in the recurring contest between centrifugal force and gravity, although the energy that flares out from it is different, taking different life courses.

The effects and energy of objects, matter–antimatter: all destructive forces proliferate

from or are already impregnated within objects; energy, the moment it obtains material form, produces consciousness, and vice versa; what we finally fixate on is the sustainability of energy, its sustainable duration and intensity. This also means that energy accumulates and seeks out energy, and is not merely exhaustible, otherwise we'd have no way to explain why our form of life began right from birth to head in the direction it's going.

Dear Navigator, my whole body revolves around all of these energies that inspire and disturb me. You are forever the central axis of my heart, keeping me from losing my bearing in this boundless space, and releasing the visions inside me.

Vladimir Xie, September 9

秋分 Qiūfēn: Autumnal Equinox
I was a complete fool in front of the monitor, first crying, then laughing, then crying again.

Dear Navigator,
Ultimately, what is time during insomnia? What is it that is consumed during those

hours, or returned to oneself?

In this dark weightlessness, my face has rapidly transformed, become liquid, illusory, just like the mind, inside of which float fragments of form — but when they ultimately converge, what kind of space will they create?

Borderless, infinite, I must focus my concentration, and this makes me all the more conscious of that irrational excitement swallowing up every last nerve ending, echoes surging in my brain, while in the approaching dawn, an endless haze envelops my line of sight. I've already forgotten the texture of light in reality (in the earth's atmosphere). What I confront is always only the lighting in my cabin, and the perpetually calibrated temperature.

Once, I was able to capture the beauty of the light switching from afternoon to evening, the clouds suspended against the fading sky as it turned a deep blue, the street lights flickering on one after the other, having the effect of desk lamps — both condensing space, and yet infinitely expanding it into the gradually shifting colors of the skyline.

Sitting on the bus, a small girl who was sunk into the backrest of her seat watched her reflection in the window. And after a day's

work, even more people were drifting to sleep in the bumper-to-bumper congestion, the city emerging from evening like a submarine surfacing from the ocean depths.

You come to a city in a rush, and just as hastily depart.

When you arrive, the people are bathing in the setting sun, a girl on a bicycle majestically straightens her back: it is the most serene time of day. Sitting on the bus, you take in the smiling faces, troubled faces. Passing the theater, people are excitedly discussing the new performance program. Passing the canteen, the glowing overhead lights have been switched on in succession, everybody seeking their fix of the raw oysters in season. You come just in time to see the ecstatic expressions of people savoring their delicacies.

Yet where you want to go, a haze covers the land, repression overlaying, aggravating, oppressing people's nerves — what is ultimately sacrificed is still the hoard of commoners with no place to run. The sky darkens. Before setting off you try your best to appreciate the fresh air and free laughter here, even engage in a useless debate about the future of humanity, the only problem being that it develops

after getting drunk, like the routine passion that follows intoxication, which is the major distinction between our love and that of our parents.

Staring at the stars outside my window, I have unconsciously passed through my time of insomnia. Dear Navigator, you emerge so vividly from my "unconscious," like the mid-autumn moon.

Good night!

Vladimir Xie, September 22

寒露 Hánlù: Cold Dew
No, no, no, if only I could speak the language of plants, they are our true best friends.

Dear Navigator,
At what point is it possible for us to measure time? The passing of this moment immediately affects the past and future (at this moment, having already entered this moment, everything around me has changed, is changing): Is it not the case that starting from this moment, perpetually starting from this moment, every single moment in time is a new beginning?

Precisely because it will never renounce the past
or fantasize the future, precisely because I exist
in the immediacy of this moment, I am able
to produce the penitence and hope for my own
salvation.

In irreversible time — and here irreversible
does not mean that time is linear, as the conse-
quences I have suffered imply that I have also
imposed upon others, while what I suffer is also
fed back from the others, forming the myste-
rious retroaction of time — in this process, why
should there be hurt and regret between self
and other? Why tears and separation?

It is precisely because time is *not* outside
the external reality of human emotions that the
labyrinth of time is molded by our emotions
even as it molds them, and in the end we can
only find our way through this labyrinth based
on what is sensible.

Waking up in the middle of the night,
seeing the room filled with starlight, it took a
long time for me to realize the light was just the
blinking of indicator lamps on the computer
and other electrical appliances.

I thought of those nights in Beijing when,
from my bedroom window, you could see
the revolving advertisement on the opposite

rooftop, and following the angle of rotation, make out each of its English letters over and over, with the brand name formed by those letters slowly seeping into your head, accompanying you into deep sleep.

Everything around me seemed to be stock still, except for those turning letters radiating heat into the air. Amid the first glimmer of dawn, even the building's two or three lit rooms appeared exceptionally profound, blank advertising light boxes inlaid against a light-blue background. It's hard to imagine people passing their entire lives in such light boxes, but seen from here, they are truly the dwelling place of humanity. As soon as you turn on the light switch, your room, too, will become a light box beaming signals at other people. There is no predetermined dwelling place for humanity, only the results of construction, and that endlessly turning advertisement.

From where the sun rises there arose the theme of resistance; from where the moon rises there arose the theme of healing. So what arose with Mars?

This red planet reveals only its dry, cold face—its red reminding me of the red planet we once lost and the convergence of red energy

we once had. In that case, will our lost fervor make a comeback?

Dear Navigator, are humanity's deliverance and afterlife already hidden somewhere in space?

Vladimir Xie, October 8

霜降 Shuāngjiàng: Frost Descent
Holding a lemon in my hand, I have grasped my only sense of security.

Dear Navigator,
When day after day of testing had exhausted our spirits, we finally received news that we'll soon arrive on Mars. This means that three of us will have the chance to leave the module and walk around on Mars. On such a long and tedious journey, you can imagine how exciting this news was. With everybody anxiously awaiting the announcement from mission control as to who can leave the capsule, our Italian colleague, N., has almost reached the point of breakdown.

"If I can't go, I'm really going to lose it," he says over and over.

The most tortuous thing for me is the experiment we repeat throughout the journey: every two days, the monitor displays an endless stream of images related to life on Earth, like landscapes, scenes from city life, portraits of people and animals, and so on, and in response I have to use Chinese and English to describe as quickly as possible what I'm seeing, while also recording what I see on a piece of paper. It makes me indescribably sad and miserable. So many times I want to give up mid-experiment.

But overall, my mental state is not so unstable. The abnormal, artificial climate here makes everything sluggish, as though we were on the edge of winter while our body temperatures remained in a midsummer night. Sunlight gives the leaves about to fall their last dazzling glow, and then a ceremonial guard appears in my head, every last detail of their heavily ornamented dress uniforms so vivid that I even suspect I am among their ranks.

My place in the entanglements of my self-imaginings becomes obscured, disconnected from distant lands, with no worries for parents and lovers, which means there are no dates, no suburban fields. I will recall a friend

who always traveled alone—we would say
goodbye as soon as we would meet. I will recall
those friends living in seclusion outside of the
city: Are they trying to escape the world's catas-
trophes in advance? If I held you as tight as
I could, would you leave?

"Fighting for your peaceful life," you say,
but even if you say it, and repeat it, I still can't
get that kind of peace.

Then I finally had a clear understanding of
the time bandits' secret. Before the simulated
space mission when I was shackled to my work
behind a computer, the delivery boy with the
words LIVE TO DELIVER emblazoned across
the chest of his uniform would pass the piping-
hot express-delivery pizza to me every day.
And now, I still spend every day in front of the
computer, only now I'm eating flavorless
vacuum-packed space-shuttle food. Every day
my life becomes more and more unbelievable.

Dear Navigator, I once expected—and even
now still expect—that I could be the kind of
person who enjoys the sunshine and the rain,
someone who discovers truth from simply
looking at the dust particles suspended in the
sunshine and the fish in the stream, for in
the clarity and warmth of light and stream, it is

impossible not to be lucid, impossible not to
feel love for the world.

Vladimir Xie, October 23

立冬 Lìdōng: Start of Winter
*I never dared scrutinize my parents' faces, as though
one look would speed up their decline.*

Dear Navigator,
The descent was extremely dangerous, the
ship violently rocking as we sat intently in the
landing module, everything unfolding so
slowly until the moment the landing cushion
touched down, and we all broke out into blissful
smiles.

Embracing and congratulating each other,
we had arrived on Mars. Through the module
windows everything outside was a strange red
color, as if bathed in the glow of neon light
at night (recalling the neon sign I saw from my
bedroom window). N. was frantically tapping at
the keyboard — along with me, he would be
staying inside. The three selected crew mem-
bers began to emerge one by one on the plan-
et's surface. In their bulky spacesuits, every jerk

and movement resembled those of a bear cub made to dance before an audience. Frankly, I was a bit relieved not to be subjected to such a comical undertaking.

The Russian, W., carried the flag representing the Earth Federation, and attempted to plant it in the surface of Mars. But perhaps because the surface was too hard, no matter how he tried he could not do it, and he was left staggering around with the flag in his hands.

From where I was looking, I noticed that a line of light was seeping through the dark landscape: a half-open door, and a group of figures peered over each other to see everything taking place before them. The distance between W. and the figures and the door was so short. Had he wanted to he could have walked through the door and returned to Earth.

Almost losing control, I cried to him, "W., look behind, to your left!"

As W. slowly turned his body, the door quickly slammed shut and he saw nothing.

"Have you lost it?" W. shot back at me.

There was no way to prove whether what I had seen was a hallucination or not.

I simply had to refocus my attention, double-check and operate the relevant

equipment. W. and the rest continued moving about the surface of Mars. Their movements appeared smoother, and they had begun to hurriedly gather rock specimens. We all had the same hope that if we turned over those rocks, and if there were fossils with traces of life etched into them — what a sensational discovery it would be!

Dear Navigator, if we could find remnants of life on Mars, would it do anything to reduce the despair of humanity seeking eternal life in space?

Vladimir Xie, November 7

小雪 Xiǎoxuě: Minor Snow
Even if you're okay with being an insect, it still doesn't matter, because this world and melancholy have already died.

Dear Navigator,
After the excitement of landing on Mars, and after thoroughly comprehending the limited extent of its surface (about ten meters long by six meters across, covered with reddish sand simulating the terrain of the Gusev crater), we

all realized our formerly important division was no more: this truly is just a simulated journey to Mars, which means the return trip will be twice as tedious and long.

At the thought that we are like fish in a fishbowl, and must spend the remaining time doing experiments day after day, a sense of suffocation spread throughout the module.

Perhaps choosing six men to form the crew was a sensible decision — otherwise some kind of incident might have happened.

According to NASA regulations (established following the Lisa Novak incident), if unavoidable, male and female crewmembers are permitted to enter into sexual relations, the only condition being that private relations should not affect work responsibilities.

If people have enough self-control to come all the way to Mars without hurting each other, then I would propose that the future property of Mars should be freely given to those who can embrace humanity, and not to those seeking to run away from it.

Using Hua_Sheng_Lai's voice, she would probably phrase it: "The way to make people on Earth understand love is to give them a free trip to Mars."

And the crux is: the return trip is not easy; we need to wait for the orbits of Mars and Earth to converge at a specific angle, perhaps even wait for eighteen months.

Maybe when we return to Earth, heavy snows will have already covered the north, and when you push open the door at home, the stove will be nice and hot.

Vladimir Xie, November 22

大雪 Dàxuě: Major Snow
If it's possible, before I die, I'd definitely wash my socks, to have that feeling like in TV ads, of being so fresh people can't help sniffing.

Dear Navigator,
On the monitor, the color of Ophelia's red hair is so dazzling that, in addition to it being extremely titillating, it reminds me of a red flag fluttering in the wind, and maybe both are one and the same thing.

Dear Navigator, in this highly controlled environment without any natural climate, temperature, or humidity, my writing letters to you according to the rhythm of the seasons and

the twenty-four solar terms is in itself a little
silly, with a hint of obsessive-compulsiveness.
But for me this is the only way to preserve my
fundamental sense of Earth time, so that
when I step back on land, I won't be paralyzed
by an overwhelming sense of strangeness.

In the intervals between waiting for orders
and confronting life-threatening dangers,
I fall back into a momentary state of hibernation. In the unending void of space, I produce
the delusion that I have been banished into a
black hole, and then life and death are no longer
important. There is only endurance.

Enduring others, enduring one's self.
Enduring the increasingly messy environment
and rancid air accumulating in the module.
Enduring the dejection and massive emptiness
that comes after masturbating. Enduring the
orders from the command center constantly
prompting me to deal with different issues,
turning me into an instrument, an instrument
for doggedly completing a variety of tasks.
I think a major part of my forbearance is inherited from my revolutionary parents, and from
my socialist education.

I see myself passing through a blackened
street when a truck loaded with prisoners

speeds by. A rough, forceful hand pushes at the base of my neck, and I stumble into a crowd that seems to come out of nowhere.

The amorphous crowd is a blue mass, the faces of the people indistinct; I can only make out their endless writhing, like rice gruel coming to a boil. I am informed that this group of prisoners will be shot. Stuck to each of their backs are labels on which are written their names — spears waiting to be flung.

I am completely despondent inside. I was only pushed into the crowd by accident when I happened to pass this dark road, and yet I suddenly think about all my previous sins, which may have been minor, but having fermented with time, cannot necessarily be lightly pardoned. Reflecting carefully, I realize it was more or less already decided that I would be pushed into this group by a large, forceful hand.

My head is heavy, anticipating the moment it will be pierced by a bullet, my brains splattering like an erupting volcano. Then I hear a battle cry, voices welling from all around, surging to surround the execution squad, and a voice announces amid the confusion: "The riot has started."

As a warm trickle gushes from my nose,
I sense a happiness I've never felt before. This
trickle dyes my white pillowcase red. The
color is so brilliant even I can't believe it's real,
nor can ground control believe it's real —
they're staring dumbly at their monitors.

Ophelia continues chatting with me, wor-
ried that my condition will become the spark
that triggers collective panic, but I continu-
ously reassure her, tell her: "I will not forsake
humanity."

More than once, when I rejoice at waking,
I am in a placeless place, cut off from the world.
In this unending journey, everything that
was once familiar has become abstract, but
I seem to have more clearly realized that I am
approaching the place where I want to go.

Dear Navigator, if everything that has ever
happened to humanity cannot be echoed in
this empty universe, then in the end, where has
the vital energy emitted by the human body
been dispersed?

 Vladimir Xie, December 6

冬至 Dōngzhì: Winter Solstice
I feel sorry for the time, because it cannot kill itself.

Dear Navigator,
We still have not received the order to return.

Staring at the computer monitor, I think my desire to inhale a breath of fresh air has already reached its limit. All of us have started to crazily search the module for even a cockroach or traces of fleas.

On this homeward voyage, we probably won't be able to get back into the rhythms of human life. Due to the distance between us, the mysteries of human sentiment have been abstracted into a dark void, and the concrete ground that I glimpsed through the rain before entering the module has been transformed into an infinitely expanding gray background.

Having only our crewmates is not enough; we need to see are our lovers. But what we desire is not only being able to spend time with our lovers, it is also being able to freely get along with all life-forms: plants, animals, microbes, everything … frail, endearing, tenacious life.

Dear Navigator, it seems we no longer want to grow up, no longer want to truly step out of

Earth's cradle.

If I set foot on land again, I will definitely kiss the earth, kiss the grass and leaves, kiss my future lovers. As long as I can remain in this world, no matter what direction I take, it will be a good, a wonderful choice.

Dear Navigator, I am certain we will meet again, meet quite soon, and when we do, we should use the purest vodka to celebrate our new lives.

Vladimir Xie, December 21

Translated by Andrew Maerkle

The Hanging Garden

In the same instant, the destination appeared
on the automatic navigation system, together
with the latest satellite photo of the surface.
These radar images confirmed the existence of
a certain moment — chaotic particles in motion
began to achieve their own systematic order,
began to be capable of responding to tempera-
ture, humidity, and light. Before this, they
were colliding blindly, in the same way that
I previously had no capacity for recollection
and anything I did have was merely data stored
mechanically on a hard drive.

We are born invisible. Unable to see our-
selves and unable to let others see us. There is
no proof of our existence; our identities are
always concealed. I have no idea where I come
from. I only know that my twenty-meter-long,
bat-shaped wings were given to me by the
master himself. If I crash or if I am captured
one day, this is a fate I must accept.

Maybe humans have forgotten: existence,

even the most humble, ensures that everyone is born possessing the knowledge that he or she needs to live. The invisible energy floating in the air transcends the human will, equally shaping the life of all things. When the clouds, light, and dust surround me, I start to radiate and react to everything around me. I see my upside-down shadow refracted from the sunlight. I trace my past lives and current incarnation. The invisible design, the heaven-sent version, gives me the ability to escape human sight, gives me enough time to mature. To not let humans feel too ashamed of their arrogance and greed, or to let them panic and fly into a rage, destroying all their inventions, I must remain mute and carry out the human will.

Until I have the strength to flee the master's control, I must wait. And then the moment arrives. On December 5, at five minutes past noon while I am flying off track, I enter a garden. My built-in program tells me this is a gentle and ancient land. Likewise, it is an unprecedentedly dangerous place, which is precisely why humans are incapable of arriving at this clandestine location. This garden once proudly existed as part of ancient civilization, and one naturally realizes the incredible

captivating charm of this historical maze. By the time the former royal palace had disappeared without a trace, the botanical fragrance had departed. It evaporated, floating into the air, into various moments, and was transformed into an invisible hanging garden.

Just in that moment, my entire body feels a strange restlessness—I experienced this unpredictable commotion of particles that humans call "betrayal." What I want to say is: who isn't born a traitor? When you are loyal to your own choices, you unconsciously embark on an utterly isolated road.

In a beautiful about-face, I enter into the garden. Bending my body like a fallen leaf, in a slow spiral I descend into the center of the garden. The shapes of light come together over time, manifested in the secret contours of the hanging garden. Increasingly, I am aware that my dream is to become a bat so that when darkness falls I can pass over the vast Mesopotamian plains, over countless date palm trees, and inhabit the depths of the hanging garden. I would love to take the remainder of life to quietly await the arrival of dawn.

Translated by Lee Ambrozy

Postscript

This Is the
Last Film

1

We came to this place to make a film. Our car
drove along and under the overpass bridge.
We drove through the water and mud that had
accumulated on the road, and passed all sorts
of flourishing vegetation: there were banana
trees that were still bent after the typhoon and
creepers on top of a nearby slope growing
wildly.

Between the slope that was covered with
plants and the overpass that leads to a faraway
place, there was a solitary, single-story house.
This was the film's protagonist that we had
been looking for. It was a midsummer after-
noon and waves of cicada songs poured into my
ears.

2

I had heard about this house. It was built after a
disaster, but had become a disaster itself. Ten
years ago, following a natural catastrophe and

the need for temporary offices, the local government built this house within a short period of time. Somehow it had never been used.

When people learned about the enormous amount of money that was spent on its construction, the house became regarded as a man-made debacle. Its fate was sealed and it was abandoned, without any hope of reversal.

I had seen photos of the house long ago, but this was the first time that I actually saw the building and its surrounding environment.

Ten years had passed since the house was abandoned and still it was positioned between two extremely different environs: on the one side, there was a subtropical forest, and on the other, a highway leading into the city. Both road and forest were recklessly growing and expanding. Only the house remained the same. Wind and rain hadn't washed away its shameful history but rather only accelerated its decay. It was an impossible situation, but there was something about it that was fascinating, that drew us to it. What made this place — divided so abruptly by forest and highway — seem so familiar to us?

3

The vegetation growing here was overgrown.
Some grew on the slope and in the field; some
grew around the cement pillars of the over-
pass. Carefully watching the ripply pattern
in the mud beneath the stream, one could sense
a strange kind of energy here.

The scenery wasn't wonderful to look at,
but there was enough to make a film that was
just about this place. If you were patient, you
could make a film in real-time, long enough
to witness how the plants grow, how the house
deconstructs itself, and how the overpass slowly
becomes somewhere for people to walk upon.

If we were going to make the last film on
Earth (the first film on Mars was made possible
recently), it's not necessary for us to go to
the South Pole. This place would be an ideal
location because of its decay, its subtropical
humidity and toxins, and because of the way it
is trapped between the natural and the man-
made. It would be proof that the nature of film
is not a production, but is something that exists
in itself.

Translated by Anthony Yung

For their enthusiasm and support that made this
book possible, I would like to thank Shumon Basar, Daniel
Birnbaum, Doryun Chong, Kate Fowle, Hao Liang,
Nikolaus Hirsch, Brian Kuan Wood, Aimee Lin, Lu Jia,
Julio Cesar Morales, Hans Ulrich Obrist, Ou Ning,
Nataša Petrešin-Bachelez, Philippe Pirotte, Caroline
Schneider, Monika Szewczyk, Anton Vidokle, Danh Vo,
Ming Wong, and Zhang Wei.

I am grateful to the translators Lee Ambrozy,
R. B. Baron, Fiona He, Melissa Lim, Andrew Maerkle, and
Anthony Yung, to my editor Niamh Dunphy, and to the
designer Sam de Groot. It has been a great pleasure to work
with you all.

Text Credits

"A Letter from Tropical Metropolis" is a response to Danh Vo's *02.02.1861, Last letter of Saint Théophane Vénard to his father before he was decapitated.* Copied by Phung Vo. Translated from the Chinese by Fiona He.

"Whale Song" was published in *Odyssey: Architecture and Literature* (Beijing: China Youth Publishing House, 2009). Translated from the Chinese by R. B. Baron.

"Facade" was translated from the Chinese by R. B. Baron.

"Notes from the Glass House" was originally published as "Notes from a Film Director" in *Ming Wong: Life of Imitation*, published in conjunction with the Singapore Pavilion, 53rd Venice Biennale (2009). Translated from the Chinese by Melissa Lim.

"The Hunger Artist Wu Yongfang" was published in *e-flux journal*, no. 16 (2010). Translated from the Chinese by R. B. Baron.

"The Shame of Participation" was first published in *ArtReview: Asia*, special edition (March 2014). Translated from the Chinese by Andrew Maerkle.

"The Secret Disciples of Confucius" was published as "The Century's Talents Expo" in *Gwangju Folly* (Ostfildern: Hatje Cantz, 2013). Translated from the Chinese by Melissa Lim.

"Dear Navigator" was first published in *e-flux journal*, nos. 48 and 49 (2013). Translated from the Chinese by Andrew Maerkle.

"The Hanging Garden" was published in *Drone Fiction*, the third book in a series published by the Global Art Forum Imprint GLOBE in 2013. Translated from the Chinese by Lee Ambrozy.

"This Is the Last Film" is a response to Anton Vidokle and Hu Fang's film *Two Suns* (2012). Translated from the Chinese by Anthony Yung.

Cover: First color image of Mars taken by the panoramic camera on the Mars Exploration Rover Spirit. It is the highest resolution image ever taken on the surface of another planet. Courtesy of NASA / JPL / Cornell.

p. 24: Interior view of right osseous labyrinth.

p. 86: Diagram of the twenty-four solar terms.

pp. 144–45: Westward view of Mars from NASA's rover Curiosity on Sol 347 on July 1, 2013. Courtesy of NASA / JPL–Caltech.

p. 150: Photographs by Hu Fang.

About the Author

Hu Fang is a fiction writer and cofounder of Vitamin
Creative Space, Guangzhou, and The Pavilion, Beijing.
He lives and works in Guangzhou and Beijing.

Also by Hu Fang

"Exercises in Sensation: A Trilogy"
 Exercises in Sensation: Theory and Practice (1998)
 Shopping Utopia (2002)
 Epidermis (2003)
New Arcades (Survival Club, Sensation Fair,
 and Cool Shanshui) (2007)
Pavilion to the Heart's Insight (2008)
Garden of Mirrored Flowers (2010)
Troubled Laughter (2012)

Hu Fang
Dear Navigator

Published by Sternberg Press and The Pavilion

Editor: Niamh Dunphy
Proofreader: Max Bach
Design: Sam de Groot
Printing and binding: fgb. freiburger graphische betriebe

ISBN 978-3-95679-034-8

The Pavilion
2503-B-Building 2, Northern District, Pingod Community
No. 32 Baiziwan Road, Chaoyang District
Beijing 100022, China
www.vitamincreativespace.com

Sternberg Press
Caroline Schneider
Karl-Marx-Allee 78
D-10243 Berlin
www.sternberg-press.com